Contents

INTRODUCTION

There is a camera in nearly every home, but many people only take photographs on holiday and family occasions. By not using their cameras more fully they miss a great deal of pleasure, for photography is a fascinating hobby.

This book will show you how to get the best from your camera. It starts by explaining how a camera works and then goes on to show ways of getting better results. If you know what is going on inside the camera you'll be able to cope with all types of conditions, and get results which will be the envy of those photographers who just take their cameras for granted.

Most of the ideas in this book can be tried with the simplest camera, yet they will produce results which are much better than average. It is nice to own an expensive camera, but the special advantages which it has may only be needed for a few shots a year. Most subjects can be tackled just as well with a very modestly priced outfit.

Photography is really a matter of seeing. Once you have learnt to look around you properly you'll be able to take pictures that are unusual and striking. You will 'see' a picture that most people would miss.

One of the best things about photography is that it is a many-sided hobby. You can use a camera in many ways and there is always something new to try. For example, the camera is a wonderful notebook. In a fraction of a second it can capture moments you want to remember – sporting occasions or the details of a scene

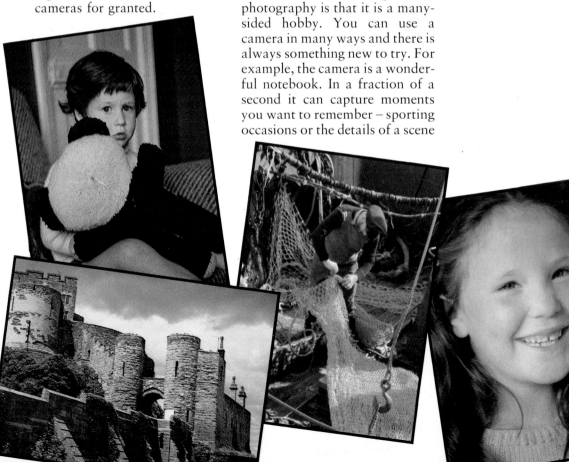

GO
PHOTOGRAPHY

● An all-colour guide packed with information for the young photographer

George Haines

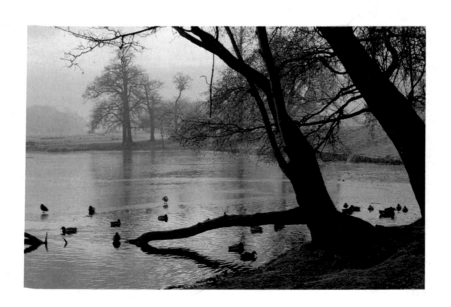

HAMLYN

Photographic Acknowledgments
Animal Graphics 85 bottom; C. Blackie 70 top, 71 top, 72 bottom, 79 top, 83 top, 103 top left and right; Crown Copyright – Science Museum 151 bottom, 155 top; P. Crump 92 bottom, 99 centre; D. Dracup 64, 74 centre, 75 bottom, 77 centre, 78 bottom, 100 top; B. Folkard 5 bottom, 59 bottom; A. Gardner 4 right, 80 top, 82 top; G. Haines 21, 29 bottom, 32 centre, 61 centre left and bottom, 71 bottom, 73 centre and bottom, 74 top, 75 top, 76 centre, 77 bottom, 98 centre bottom, 100 bottom, 114, 137 bottom; David Halford 110 bottom; Hamlyn Group 12, 26 (all three), 32 top, 33 top and bottom, 80 bottom, 82 centre, 84 bottom, 101 (all four), 105 top and bottom, 106 top, 108 top and bottom, 109, 120 top, 145; J. Herridge 89 bottom; M. Herridge 13 top, 103 bottom; L. Jones 32 bottom, 97; J. Kelly 4 top left, 20 top and bottom, 29 top, 38 (all four), 58 (all four), 59 top, 60 (all four), 61 top and centre right, 63 top, 68 (all three), 69 left and right, 70 top, 72 top, 76 bottom left and right, 78 top, 85 top, 86 centre, 90 bottom left and right, 90–1, 91 (all five), 96, 99 top and bottom, 100 centre, 102 (all three); Kodak Museum 151 top, 153 top and bottom, 154 top and bottom, 155 bottom; M. L. Lim 4 bottom left, 84 top, 86 top, 94 top, 95 bottom left and right; P. Macdonald 5 top right, 98 bottom, 135, 136, 138; M. Mackenzie 62 bottom, 76 top; D. Morgan 37, 57, 79 bottom, 81, 93, 106 bottom, 120 centre bottom, 137 top; I. Muggeridge 4 centre, 5 top left, 14, 36 (all three), 56, 62 top, 63 bottom, 73 top, 77 top, 82 bottom, 86 bottom, 87, 88, 89 centre, 90 centre, 98 top, 111 top and bottom, 112 left and right, 113 left and right, 120 centre top and bottom; National Portrait Gallery 157 top and bottom, 158 top; The Picture Company 146 bottom; M. Reeves 92 top, 98 centre top; Tony Stone Associates 110 top; Syndication International 146 top; J. Todd 7, 13 bottom, 74 bottom, 83 bottom, 84 centre, 89 top, 90 top, 94 bottom; US Signal Corps 152; Victoria and Albert Museum 158 bottom; S. Watts 6; ZEFA – Bob Croxford 92 centre; Trenkwalder 95 top.

Front jacket: ZEFA Picture Library
Back jacket: David Kilpatrick
Illustrations: Tony Streek, Raymond Turvey

This edition first published in 1987 by
The Hamlyn Publishing Group Limited
Bridge House, 69 London Road, Twickenham, Middlesex.

Copyright © The Hamlyn Publishing Group Limited 1982, 1987

ISBN 0 600 53174 0

Printed in Hong Kong by Mandarin Offset

First published 1982 as *The Young Photographer*
This edition revised and reset

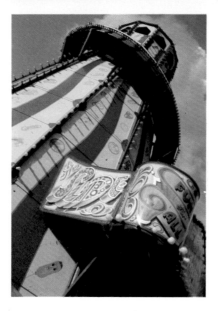

or a building or a friend's face that an artist would need several hours to record.

Photography can be coupled with your other hobbies too. If you are interested in old buildings, cars, churches or natural history, you can build up a collection of prints which will help you to remember your most exciting finds and to share them with other enthusiasts.

Old photographs are fascinating. In the future the photographs you take now will be old, so it is worth recording clothes, means of transport and other everyday things which you take for granted. They will seem very strange to your children and your grandchildren.

Some photographers find photography so interesting that it becomes a hobby on its own. It is fascinating trying to take 'impossible' subjects and making pictures from unlikely scenes. Or if you have a scientific mind you can experiment with development processes and new films.

In whichever way you see your camera it will make you look around with more interest. And you'll find that, unlike some hobbies, it has no 'off' season. There is always something to do and try.

Finally, because photography is so full of interest, it makes for enthusiasts and you'll find using your camera will lead to new friendships as you share your enthusiasm for photography with others.

5

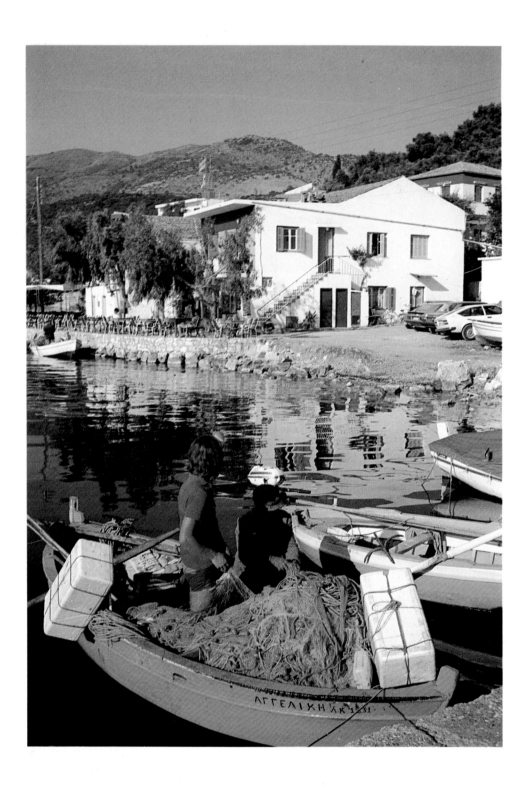

HOW A CAMERA WORKS – IN PRINCIPLE

▷ Light travels in straight lines.

To get the best possible results from your camera you really need to understand the basic principles on which it works. Then you can appreciate the limitations – and advantages – of the camera you own and be familiar enough with its workings to make quick adjustments and to understand why you should make them.

Light

In a dark room it is hard to see objects clearly. If it is completely dark you can't see your hand even if you wave it in front of your eyes. In the same way that our eyes need light to see, a camera needs light to produce a picture.

The light we most often use to take a picture is light from the sun, but it is also possible to use 'artificial' light – from electric lamps, candles or an electronic flash specially manufactured for photographic use. The word photography comes from the Greek and literally means writing or drawing with light.

All light travels in straight lines. Individual rays of light travel outwards in all directions from any light source – whether it's a candle, a light bulb or the sun.

When the light rays from a light source strike an object they are thrown back or reflected – again travelling in straight lines. Most of the things we see do not give off light of their own. We see them because they reflect some of the light that comes to them from a light source. When the reflected light enters our eyes we see the object.

Pinhole camera

By making and experimenting with this simplest possible form of camera you can see in action the basic principles by which every camera, no matter how sophisticated, works.

When you have made the camera, place a lighted candle about a metre in front of the pinhole. In a darkened room you will be able to see an upside-down image of the flame on the greaseproof paper screen at the back of the camera.

The image is upside down because light travels in straight lines. Light from the top of the flame passes through the pinhole and reaches the bottom of the image. Light from the bottom of the flame passes through the pinhole and reaches the top of the image. The image is also reversed left to right.

The pinhole camera shows that in order to produce an image of a subject on a screen there must be some way of restricting the number of light rays reflected from the subject. If you just hold a piece of greaseproof paper in front of a candle you won't get an image of the candle on it because every part of the candle is sending light rays to every part of the paper. The resulting 'jumble' of light rays illuminates the whole piece of paper. But by making the light from the candle pass through a small hole before reaching the greaseproof paper screen, each part of the screen will only receive light from one part of the candle.

Camera obscura

The pinhole camera is a small version of the camera obscura – a device which has been known for centuries (*see page 149*). A camera obscura is a darkened chamber into which light is only allowed to enter through one small hole. An image of the scene outside is produced on the wall opposite – upside down of course.

Enlarging the pinhole

Having emphasized the importance of restricting the light rays entering the camera, it is interesting to see what happens if you enlarge the pinhole.

Light rays diverging from the candle continue to diverge after

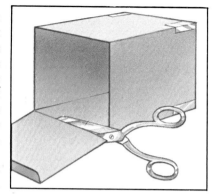

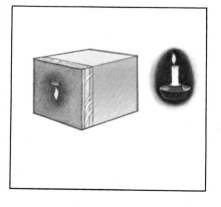

How to make a pinhole camera

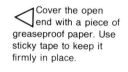
To make a pinhole camera you will need: small cardboard box, scissors, sticky tape, pin, piece of greaseproof paper, piece of tinfoil, candle. Cut one end off the box. Re-inforce the corners and edges if necessary.

Cover the open end with a piece of greaseproof paper. Use sticky tape to keep it firmly in place.

Cut a small hole in the other end of the box and cover this hole with a piece of tinfoil. Make a pinhole in the centre of the foil.

Ask permission to light a candle. Put it in front of the pinhole. In a darkened room you will see an upside-down image of the flame on the greaseproof paper screen.

8

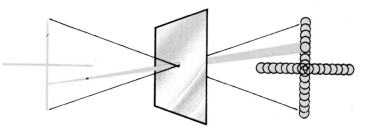

▷ Light rays diverging from a light source continue to diverge after passing through a hole. Even with a tiny pinhole the image is not very sharp as the light reaches the screen as tiny discs of illumination.

passing through the hole, and even with a very tiny hole you have probably noticed that the image is not very sharp. This is because the light reaches the screen as tiny discs of illumination.

Obviously if the hole is enlarged the discs will become bigger and the image less sharp. It will, however, become brighter because more light is reaching the screen.

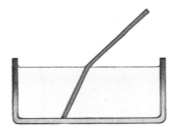

▷ The effect of refraction – a straight stick appears bent under water.

How a lens works

You may be wondering by now why your eye sees everything so sharply. The reason you can see clearly is because, as well as a light restricting pupil, your eyes each contain a lens. If you can't see clearly then something has probably gone wrong with the lens in your eyes and you need to wear a lens outside your eyes – as glasses – to correct this.

Lenses work on the principle of *refraction*. The speed of light through the air is constant, but when light passes through another medium – glass or water for example – it is slowed down and this causes the light rays to be bent or *refracted*.

▷ Light is refracted on passing through clear glass but is re-refracted on passing out along its original path.

The effect of refraction can be seen by placing one end of a straight stick in a bowl of water. The part of the stick beneath the surface of the water appears bent because the reflected light by which we see the top of the stick is travelling at a different angle from the light by which we see the bottom of the stick.

▷ A converging lens brings parallel rays of light to a point – called the point of focus.

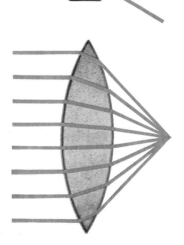

The lens used in a camera is, in its simplest form, a disc of glass, ground and polished so that it is

9

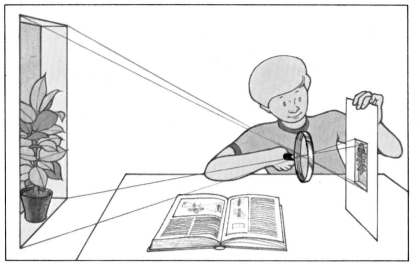

You can form an image on a piece of paper using a magnifying glass. Be careful though: you can burn holes in paper if you focus the sun's rays through a magnifying glass.

thinner at the edge than in the centre. Most modern cameras, however, use a combination of lenses of varying shapes to improve the sharpness of the image. Some lenses are now made of plastic.

The camera lens accepts the ever-widening rays of light reflected from every point on the subject in front of it, and, by refraction, makes them converge to points again which collectively make up an upside down, reversed left to right, bright, clear, image.

The principle can be seen with a simple magnifying glass. Stand well back from the window of a room and by using a magnifying glass you can get an image of the window and the scene outside on a sheet of white paper held vertically. By keeping the position of the paper fixed and moving the lens backwards or forwards the image of the plant on the windowsill or the trees in the garden can be made sharper.

Focusing the image

Using a magnifying glass is an excellent way to demonstrate several factors about lenses.

To get a sharp image of the plant on the windowsill on your piece of paper you had to hold the magnifying glass in position. To get a sharp image of the tree outside, the glass had to be moved to another position. After doing several experiments you will realize that the nearer the subject, the further the lens has to be from the paper to get a sharp image.

If you put the magnifying glass lens into your pinhole camera (in place of the pinhole), you will find that you now need some way of altering the distance between the lens and screen to focus a sharp image of the flame. This is because a lens can only be focused sharply on one distance at a time, and to achieve sharp focusing the distance between the lens and the screen on which the image is focused has to be correctly adjusted.

Fortunately the area of sharp focus falls off slowly and there is an area in front of and behind the object on which the lens is focused which is acceptably sharp. If this was not so photographs would show scenes with a line of sharp focus standing like a

If you looked through a lens which was focused on the little boy, this would be the result. The boy would be in sharp focus while the dog in the foreground and the trees behind would be 'fuzzy' and out of focus. The area of sharp focus – the depth of field – would extend a little way in front of the boy and somewhat further behind.

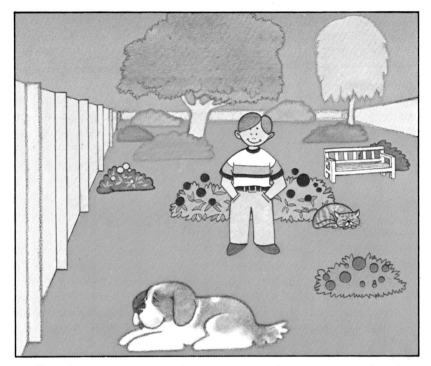

cardboard cut out in an unsharp scene.

The depth of the acceptably sharp zone is referred to as *depth of field*.

Focal length

Every lens has a 'bending power'. That is, the make-up of a lens determines at what distance from the lens a sharp image will be formed. The point where the image is focused (be it a piece of paper when you are focusing images through a magnifying glass or a piece of film in a real camera) is called the *focal plane*. The distance from the lens to the focal plane when the lens is focused on a very distant object (defined in photography as infinity) is called the *focal length* of that lens.

The standard lens for a camera has a focal length approximately equal to the diagonal of the

Focal length

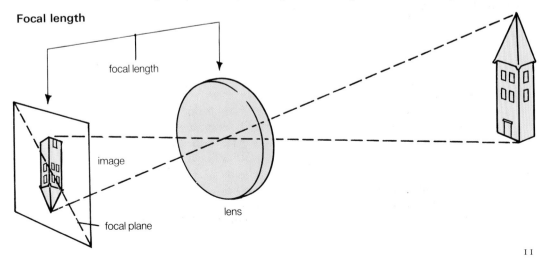

focal length

image

lens

focal plane

picture area. This produces a 'normal looking' picture.

The longer the focal length of a lens the bigger the image it will produce. For example – a lens with a focal length of 100 millimetres (always expressed in photography as a 100 mm lens) will produce an image twice as big as a 50 mm lens.

Small, simple cameras have a lens with a short focal length which produces a tiny image on a narrow strip of film.

For special purposes a camera may be fitted with a lens of shorter or longer than normal focal length. The shorter than normal lens gives a smaller than normal image and has a wider angle of view; the longer focal length lens gives a larger sized image and has a narrower angle of view. (For more on the use of long and short focal length lenses *see page 111 onwards*.)

Recording the image

Your pinhole camera now has a way of producing a clear, sharp image but it has no way of recording that image. The whole point of owning a camera is to have a permanent image of a particular scene, so the grease-proof paper screen needs to be replaced by something which is so sensitive to light that it can accurately record all the tones and shadows of the image which is allowed to fall on it.

Light is a powerful force. Coloured fabrics and paintwork fade if they are constantly exposed to strong sunlight. If you take down a picture which has been hanging on the wall for a long time you will probably find that the wall behind the picture is darker than the surrounding paintwork or paper. However, this process takes a long time and the 'image' is not permanent – if the painting is left off the wall, the darker patch will begin to fade as well.

To record a permanent image of a scene or person something infinitely more sensitive to light than fabric or paint is needed.

What actually records the image in a camera is, of course, a piece of film. A photographic film is a strip of transparent plastic coated with chemicals which are sensitive to light. Of course black and white and colour film differ considerably in their make-up so let's look first at black and white film as this is the less complicated of the two.

How black and white film works

One side of a black and white film is coated with gelatin – called the emulsion. Suspended in this are salt crystals made up of silver chloride, silver bromide and silver iodide. These are called silver halides. When light is allowed to fall on these crystals they are altered by it. The more light

A black and white negative. Where little or no light reaches the film the negative is more or less transparent.

which falls on them, the more they are affected.

When the film is taken out of the camera and put in developing liquid, all the crystals on which light fell turn into metallic silver. So where a lot of light has struck the film (for example where it was reflected from a sunlit stretch of water) there will be a dense patch of metallic silver. Where little or no light has struck the film there will be little or no conversion to metallic silver and that area of the film will be more or less transparent.

This explains why the first sight of a black and white photograph you have if you do your own developing is as a *negative* – the white parts are black and the black parts white.

The paper that the final print is made on is, like the film, sensitive to light as it is also treated with silver halides. To make a print from a negative, light is passed through the negative on to a piece of this light sensitive paper. The light can pass easily through the transparent or semi-transparent areas of the negative – so (when it has been developed) the paper beneath those areas is darkened. The sunlit water, very dark on the negative, will let through very little light to the paper and thus appears white and bright on the finished print.

How colour film works

Colour films come in two main types – colour print film and colour slide film. Colour prints are made from negatives and enlarged on to light sensitive paper in the same way as black and white prints. The difference here is that the film and the paper have three layers of emulsion – one for blue, one for green and one for red.

The top layer of the film is sensitive to blue, the middle to green and the bottom to red. Colours which are a combination of these three colours are recorded on two or even three of the layers. When the film is developed a colour negative is produced.

Colour print film is also called colour negative film (as the film produces a negative image).

Colour slide film (or colour reversal film as it is sometimes called), however, produces positive images. These pictures can only be as big as the film you put in your camera as the finished pictures are actually on that piece

▷ A colour negative. Prints are produced from the negative. This sort of film is called colour print film or colour negative film.

▷ A transparency. This sort of photograph is produced directly on to the film in the camera. It does not go through the negative stage.

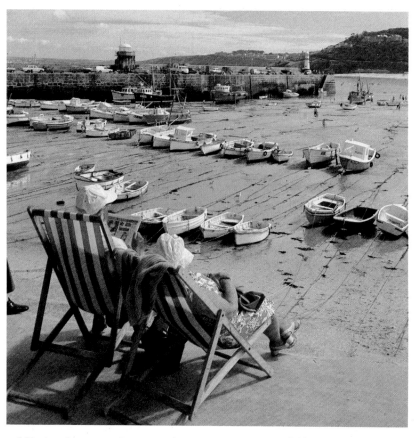

Figures in the foreground provide added interest.

of film and you need a magnifying viewer or a projector to see them properly (*see page 142*).

It is possible to have prints made from slides or transparencies, as they are sometimes called, and slides made from colour negatives, but these special processes cost extra.

Reversal films usually have names ending in 'chrome', and the names of negative films often end in 'color'. Check carefully that you ask for the right kind when making a purchase.

Shutter

This brings us to the need for a device to regulate the amount of light falling on the film when it is in the camera. Imagine you have put a piece of film in your pinhole camera in place of the paper screen. With a pinhole camera, the hole lets in so little light that an exposure would take a long time, and it would be sufficient to stick a piece of paper over the hole when enough time had elapsed to record an image on the film. With a camera with a lens, exposures may be only fractions of a second and a very accurate control is needed.

Real cameras have a shutter – a means of covering and uncovering the hole in front to regulate the length of time during which light is admitted. The length of time that the shutter stays open can be varied on many cameras. Except on very dull days an exposure of only a fraction of a second is needed.

As well as being able to control the length of time during which light is allowed to enter the camera, many cameras also have a way of regulating the amount of light which falls on the film by changing the size of the hole in the front of the camera.

This hole is called the *aperture*. (It is sometimes also called the *stop* because it stops or controls the amount of light passing through the lens.)

The aperture acts like the iris of a human eye. You have probably noticed how in bright lights your iris expands leaving only a small pupil. Light enters your eye through the pupil, so in bright light the iris expands to cover the pupil and prevent too much bright light entering. In dim light the iris shrinks and the pupil is much larger.

In exactly the same way the photographer uses a large aperture in dim light and a small one in bright light. To allow the aperture to be widened evenly, a series of thin metal blades called a *diaphragm* is used.

Viewfinder

One last thing our basic 'pinhole' camera needs – a viewfinder to show you exactly what you are going to get in your picture. Viewfinders work in different ways on different types of camera, as the next chapter shows.

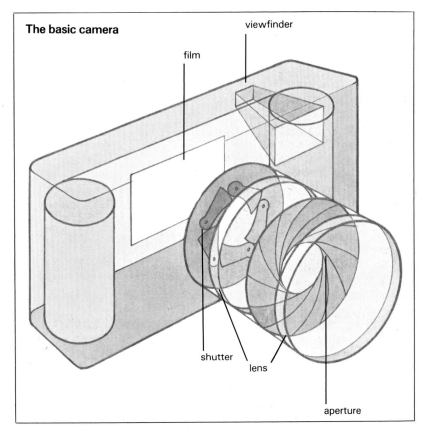

The basic camera

viewfinder

film

shutter

lens

aperture

HOW A CAMERA WORKS – IN PRACTICE

The previous chapter described the basic principles on which every camera depends. This chapter looks at the way in which those principles have been put into practice on different types of camera. That is – here we look at the actual knobs, levers and dials you will find on a camera, explaining how they work individually and, very importantly, how they work in relation to each other.

Don't give up if you find your camera doesn't have all the more elaborate controls described here. You can take excellent pictures with a very simple camera: so much of what makes a good photograph depends on the photographer's inspired way of seeing a subject or his or her quick reactions. And reading this you may well find that your apparently 'simple' camera has more scope than you realized.

Anyway if you do take photography at all seriously it is worth knowing the basic rules for using a more sophisticated camera – you never know when some kind friend or relative might let you borrow their more expensive camera.

There are many different types of camera available and, increasingly, new developments in camera technology mean that calculations and adjustments that once had to be made by the photographer can now be done by the camera. It is very important that whatever type of camera you are using, you read its instruction booklet.

Viewfinder

The only way for the photographer to know *exactly* what won't and what will be in his or her photograph is for him or her to see the image formed by light passing through the camera's lens. That is, to see exactly the image that will fall on the light sensitive film. The easiest way to do this is to place a ground glass focusing screen at the back of the camera as was done in old plate cameras. This could be done because the plates (the old equivalent of our modern film) were in light-tight slides which could easily be removed so the photographer could see the image on the screen and then put the plate back in. It is not so easy to use such an arrangement with film, so in an eye level reflex camera the image is *reflected* into the viewfinder. But this involves an arrangement which is too costly and complex an arrangement to be included in a simple camera.

Direct viewfinder
The owner of a simple camera has a *direct viewfinder* which works rather like a back-to-front telescope set inside the top of the camera. This gives a reduced size view of the scene in front of the camera. Because the lens and the viewfinder are several centimetres apart they do not see exactly the same areas. (Try looking at the room you are in with first your left eye covered and then the

Direct viewfinder

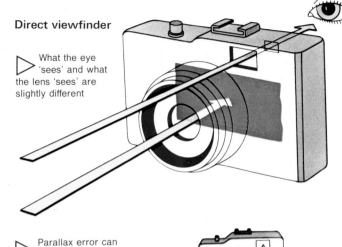

▷ What the eye 'sees' and what the lens 'sees' are slightly different

▷ Parallax error can mean you lose part of the picture

△ The viewfinder may have 'parallax compensation' marks; when photographing a subject nearer than 2 metres, frame it inside the inner marks

Reflex viewfinder

right.) The difference is called *parallax error*. It is most obvious in shots of objects near to the camera.

When taking shots at one to two metres, remember to allow for parallax error. This will avoid heads getting chopped off!

The viewfinder may have marks or a bright line indicating what will fall within your picture. Some have extra marks within the main frame to allow for parallax error at close distances.

Some more advanced 'direct vision' cameras have ways of compensating for parallax error, but this sort of camera is very expensive and generally only used by professional photographers.

Reflex viewfinding

Most sophisticated cameras use some form of *reflex viewfinding* system. This means that the camera is designed so that the image the photographer sees in the viewfinder is the same image that will fall on the film when the shutter is released.

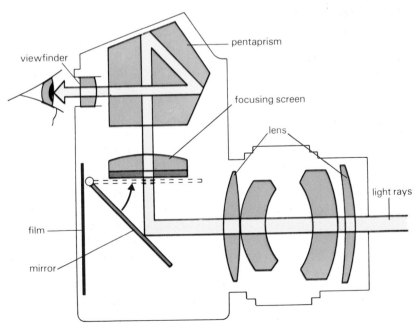

pentaprism

viewfinder

focusing screen

lens

light rays

film

mirror

A single lens reflex (SLR) camera has probably the most satisfactory system. After light has passed through the lens of an SLR camera it strikes a mirror which is angled to reflect the light up towards the viewfinder. The image of the subject being photographed is then formed on a horizontally mounted, ground glass screen above the mirror, rather than on the film at the back of the camera. From here it is reflected through a five-sided block of glass called a pentaprism into the eyepiece of the viewfinder. The image is reflected across the roof of the prism, avoiding the upside-down and left to right reversal which would otherwise be produced.

When the shutter button on an SLR camera is pressed the mirror flips out of the way so that the image no longer falls on the ground glass screen, but on the film at the back of the camera. This system does have the slight disadvantage that at the moment of exposure the image in the viewfinder disappears momentarily.

The great advantage is that the photographer sees the image that will fall on the film. Most cameras of this type have interchangeable lenses which give different fields of view (*see page 111*). Reflex viewfinding ensures you know what end result you will get with any particular type of lens.

Twin lens reflex viewfinder

As its name implies the twin lens reflex camera has two lenses. This type of camera is now rare, but it does have certain advantages. The camera has two lenses with identical focal lengths. One

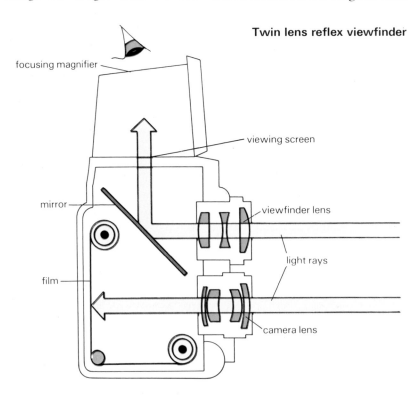

Twin lens reflex viewfinder

focusing magnifier

viewing screen

mirror

viewfinder lens

light rays

film

camera lens

is used to take the picture and has a shutter and aperture, the other is used solely as a viewfinder. The light entering through the viewfinder lens is reflected up on to a focusing screen at the top of the camera via an angled mirror. An advantage is that the image remains on the focusing screen while the exposure is made. The disadvantages are that the image on the screen appears reversed left to right, and parallax error can be caused because of the differing viewpoints of the two lenses. This can be compensated for – the owners of some twin lens reflex cameras can add on two close-up lenses of identical focal length – but the one added to the viewfinder lens has a built-in prism to compensate for parallax error.

Focusing

A focus control moves the position of the lens relative to the film, so that the light rays reflected from the subject you've chosen to focus on, fall as a sharp, clear image on the film.

The very simplest kinds of camera do not need focusing. Such cameras have lenses with a short focal length and they also have small apertures. The shorter the focal length of a lens, the greater the depth of field it has (*see page 11*), and with a small aperture everything over about 1·5 metres from the camera is in focus (*see page 24*). This means that simple cameras can therefore be produced with no focusing control.

Other simple cameras may have a very simple focus control marked with symbols or symbols and distances. The symbols

Simple focus control

indicate settings suitable for different subjects.

Adjustable focusing

On a camera with adjustable focusing you can focus on any distance indicated on the focusing scale. With this control you can achieve unusual effects. When you focus the camera on something close to you, distant objects are less sharp. When you focus on a distant subject, the foreground is less sharp. This *differential focusing* can be effectively used to blur out fussy or ugly backgrounds or to give special emphasis to the most important elements of your picture.

The *depth of field* on a camera with adjustable focusing (how much of the area in front of and behind the chosen distance is in focus) depends on three things: the distance focused on, the focal length of the lens and the size of aperture used.

The nearer the subject is to the camera, the shallower is the depth of field, so accurate focusing is much more important at short distances. And there is always a greater zone of sharpness behind the subject focused on than in front.

In a general sense you usually want as much as possible of the

Advanced focus control

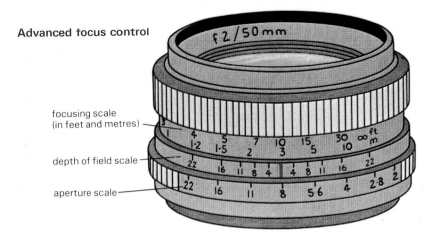

focusing scale
(in feet and metres)

depth of field scale

aperture scale

shot to be in focus. As the depth of field stretches behind and in front of the point focused on you need to know the nearest point at which the lens can be focused while still keeping subjects in the far distance sharp. This is called the *hyperfocal point*.

The lens of a simple 'non-focusing' camera is set at this distance so that it can be used without bothering about focusing except in the case of subjects which are very close to the camera.

The focal length of a lens affects the depth of field in as much as the shorter the focal length of the lens the greater the depth of field it will have.

The effect of aperture on depth of field is looked at on *page 24*.

Focusing accurately

Most compact cameras now have automatic focusing. There are two systems. In one an infra red beam is projected from the camera and the angle at which it returns to the camera is measured. In the other the contrast in the detail of the subject is measured. When the subject is sharply focused the contrast is greatest. A micro motor moves the lens to the correct focus.

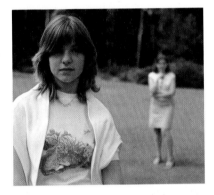

Here, the photographer focused on the girl nearest the camera.

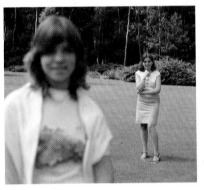

Here, the photographer focused on the girl at a distance from the camera.

In simple cameras the system has only two positions – 'near' and 'far'. In more sophisticated cameras there is a continuous range of focus.

In most cases the area focused on is in the centre of the frame because this is usually where the most important feature is. If the main feature is at the side of the

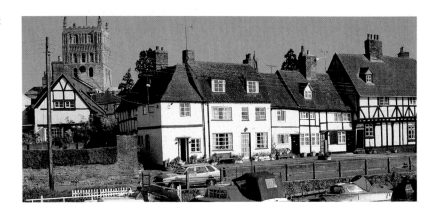

This type of subject is ideal for the non-focusing camera or a focusing camera set at infinity.

SLR viewfinder showing microprism

SLR viewfinder showing split image

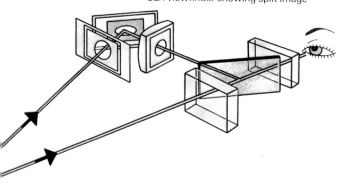

Direct viewfinder rangefinder

picture the camera can be focused on this and then swung round holding the focus on the focus lock. Your instruction book will explain how this feature operates. If your camera does not have automatic focusing you will have to adjust the focus manually.

As has just been explained accuracy in focusing is more important at close range as the depth of field is much shallower. If you are taking a close shot you should measure the distance from camera to subject. A useful dodge to judge distances is to imagine yourself lying on the ground and to estimate how many 'bodies' it takes to reach the subject. Make sure you know how tall you are!

Some more expensive cameras have various gadgets to assist in focusing. On some cameras, when you look through the viewfinder, you will see a double or split image or just a small fuzzy area in the centre of the viewfinder if the camera is not focused properly. As the focus control is moved to the correct position, the distortion disappears.

This effect is achieved in different ways on different cameras. On a camera with a direct viewfinder there may be a *rangefinder* focusing system. On

the front of the camera there is a second small opening some distance from the window of the viewfinder. A system of mirrors reflects the image from this rangefinder into the viewfinder where it forms a superimposed 'ghost' image. As the focusing control is turned, the mirror also moves and so the image from the rangefinder moves. When the images from the rangefinder and from the viewfinder coincide, the subject is in sharp focus.

With a single lens reflex or twin lens reflex camera the light passing through the lens is reflected on to a focusing screen and then into the viewfinder so that, in theory, the photographer should be able to see from the screen if the picture is in focus. But some people find it difficult to focus on a ground glass screen, particularly in dim light. So various additions to the screen have been made on some makes of camera to provide a focusing aid.

Some screens have a 'split image' or focusing screen rangefinder in the centre. If the camera is incorrectly focused part of the picture will appear 'split'. Adjusting the focusing control will resolve the split image.

Some screens have a cluster of microprisms in the centre which appear as a fuzzy patch when the image is not focused properly.

Exposure

Many modern cameras set the exposure automatically. In order to get the greatest advantage from this useful feature you need to understand fully both the principles of choosing aperture and shutter speed.

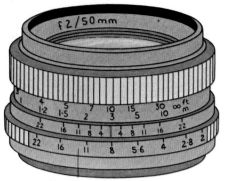

aperture control ring

Symbols on a simple camera

Aperture

The previous chapter explained how changing the size of the aperture affects the amount of light which can enter the camera. Obviously a large aperture lets in more light than a small one and in bright, sunny weather you need a small aperture to prevent too much light entering the camera. If too much light enters, the negative will be very dark and difficult to print. If reversal colour film is used, the result will be pale.

On a dull day or in a shady place the camera will need a larger aperture to allow sufficient light to reach the film. Too little light will result in a pale negative and a dark transparency if reversal film is used.

Your camera may have no way of controlling the aperture. This means it will have an aperture fixed at a certain size. And it will be a small hole because a small aperture gives a greater depth of

How the aperture works

▷ Most apertures are made from sets of thin metal blades – when the control ring is turned the blades move smoothly to increase or decrease the size of the aperture

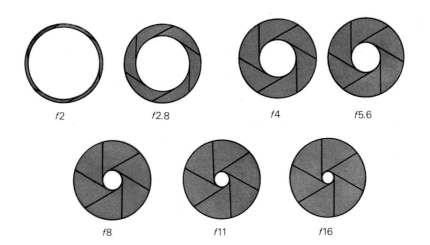

f2 f2.8 f4 f5.6

f8 f11 f16

field – that is, the smaller the aperture the more of the picture will be in focus. So if you have a camera with no aperture adjustment it really is best to use it only in good lighting conditions. This type of camera will produce superb pictures on a sunny day.

Some cameras have symbols indicating the correct setting for different weather (and therefore lighting) conditions. You just have to move a dial or switch to the appropriate symbol. The simple controls could be altering the aperture and/or the shutter speed (*see page 28*). To the owner of one of these straight-forward cameras the exact nature of the changes made by this control do not greatly matter – although the instruction booklet which accompanies the camera may explain the technical details. Just use the setting which seems most appropriate in the weather conditions at the time.

Adjusting the aperture

More expensive cameras have a more elaborate aperture control where the different sizes of aperture are measured in what

are called *f numbers* or *stops*. These appear rather confusing as the smaller the *f* number the larger the aperture but there is a logical reason for this and once you understand it, it is easier to remember how to set the aperture correctly.

The *f* number is the ratio of the focal length of the camera's lens to the diameter of the aperture. The diameter of the aperture controls the amount of light allowed into the camera and the focal length of the lens determines the size of the image over which this light must be spread (*see page 11*), so dividing one by the other gives a good measure of the intensity of light falling on the film.

For example, if the focal length of the lens on your camera is 50 mm and the diameter of the beam of light allowed through the aperture is 25 mm, then that gives you $50 \div 25 = 2$ or an aperture of *f*2.

If you then stop the aperture down somewhat, reducing the diameter of the beam of light allowed through to 6·25 mm, then $50 \div 6\cdot25 = 8$ – giving an aperture of *f*8.

So the larger the *f* number the smaller the aperture. For convenience the aperture settings are usually arranged in a sequence something like this: *f*2, *f*2.8, *f*4, *f*5.6, *f*8, *f*11, *f*16. Each number in the sequence lets through half as much light as the previous number. Thus *f*2.8 lets in half as much light as *f*2 and twice as much light as *f*4.

Cameras with an aperture control vary as to the number of settings this control gives. A large aperture lens is expensive to make so on a lower-priced camera the largest aperture may be *f*8. Some cameras can have the aperture as wide as *f*1.4 or as narrow as *f*22 or *f*32.

On the lens mount of all but the very simplest cameras there is inscribed the maximum aperture at which the lens can be used and its focal length.

The choice of aperture setting affects not only the amount of light passing through the lens, but also the depth of field. The smaller the aperture used, the greater the depth of field.

Aperture and depth of field

The size of the aperture used has a very important effect on depth of field. As previously explained (*page 11*) depth of field is a term which need only really concern you if you have a camera which can be focused. If you can focus your camera at a specific distance – for example three metres – then you will want to know what area in front of and behind that three metres point will be in focus.

As you can't alter the focal length of an ordinary lens, and you can't always position your subject in a 'convenient' position it is very useful to know that reducing the aperture increases

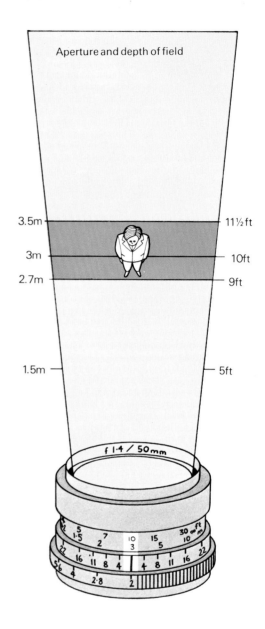

Aperture and depth of field

3.5m — 11½ft
3m — 10ft
2.7m — 9ft
1.5m — 5ft

f 1·4 / 50mm

**Lens is focused on 3 metres.
Aperture is set at *f*2.**

Look on the depth of field scale between 2 and 2. Look up to see what distance this gives on the focusing scale. The depth of field extends only from 2·7 m to 3·5 m.

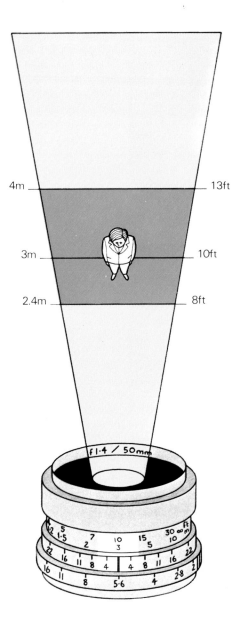

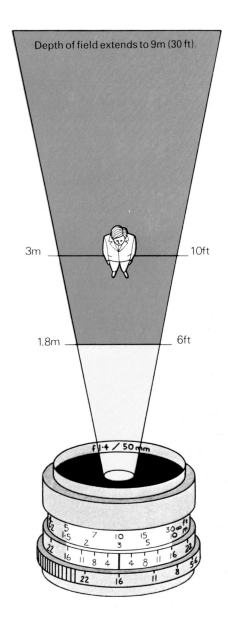

Depth of field extends to 9m (30 ft).

**Lens is focused on 3 metres.
Aperture is set at f5·6.**

Look on the depth of field scale between
5·6 and 5·6. Look up to see what distance
this gives on the focusing scale. The
depth of field extends from 2·4 m to 4 m.

**Lens is focused on 3 metres.
Aperture is set at f16.**

Look on the depth of field scale between
16 and 16. Look up to see what distance
this gives on the focusing scale. The
depth of field scale extends from 1·8 m to 9 m.

depth of field – that is, reducing the aperture increases the amount of the scene in front of you which will be in focus.

Different cameras have different ways of showing what the depth of field is at different settings. For example, focusing lenses on most cameras have marks on the lens mount which show the depth of field at different focusing distances and different apertures. Or you may have to look in the camera's instruction booklet to find a table giving the information.

The aperture setting you choose for a shot depends, of course, on the amount of light available but it also depends on other variable factors such as the best shutter speed to use for the subjects you want to photograph, and your choice of film. So a full explanation of the right choice of settings cannot be made until the workings of the shutter and the effect of using different speeds of film have been explained.

Shutter

The shutter on a camera is a device which can literally open and close in a wink. Except on very dull days an exposure of only fractions of a second is required. A fast shutter speed, only exposing the film for a very short time, is needed in very bright light. A slow shutter speed, exposing the film for a longer period, is needed in poor lighting conditions.

As well as regulating the length of time light is allowed to fall on to the film, shutter speed also affects the amount of 'blur' that appears in a photograph of a moving object. As you can imagine, the longer the shutter stays

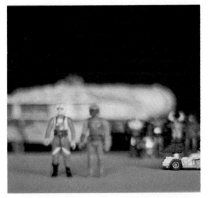

This picture was taken using a very large aperture – f2. The figures right in the foreground are blurred and so is the background.

This picture was taken with an aperture of f5.6. More of the picture is in focus.

This picture was taken with an aperture of f16. Most of the picture is in focus with an aperture this small.

open, the further a fast moving object has travelled and the more blurred a photograph of it will appear. So to take a picture of someone running or a moving car, without too much blur, you need a fast shutter speed. (The choice of speeds is discussed on *page 97*.)

There are two main types of shutter on modern cameras,

either of which may be mechanically or electronically operated.

Between lens shutter: This is the type usually fitted to cameras with non-interchangeable lenses. It is built into the lens and consists of a series of blades which open and close rapidly.

Focal plane shutter: This type is usually fitted on cameras with interchangeable lenses. It operates close to the film and consists of two blinds arranged with a gap between them which pass across from one side of the picture area to the other. Usually the blinds travel at a constant speed, and the amount of the exposure is governed by the width of the gap.

The fact that the shutter is not inside the lens means that the lens can be changed in mid-film without the film being exposed and that the single lens reflex system of viewfinder can operate – the light passing through the lens can be reflected up into the viewfinder without there being a shutter in the way.

Using the shutter

If your camera doesn't have a choice of shutter speeds there is no need to worry. A simple camera with no way of altering the shutter speed can be used perfectly satisfactorily in most reasonable lighting conditions. And there are ways of taking interesting shots of moving objects without a very fast shutter (*see page 96*).

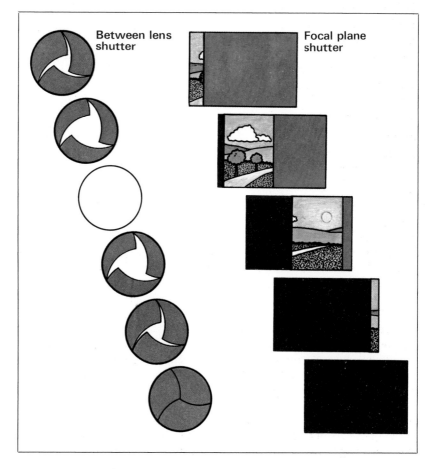

Between lens shutter

Focal plane shutter

Shutter speed dial

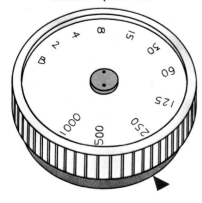

In the case of some simple cameras there may be a choice of two speeds – for example, a faster one marked 'sunny' and a slower one marked 'dull'. These simple controls may also alter the size of the aperture (*see page 22*).

More sophisticated cameras have a wide range of shutter speeds – for example: 1 second, 1/2 second, 1/4 second, 1/8 second, 1/15 second, 1/30 second, 1/60 second, 1/125 second, 1/250 second, 1/500 second and often 1/1000 second.

In this sequence each shutter time is half as long as the one before. The speed setting dial will show the speeds available on a particular camera. As space on the dial is limited, fractions are often shown abbreviated to whole numbers, but in a different colour.

Some modern cameras with automatic exposure control may have electronic shutters which open automatically for whatever the correct exposure time is. They are not limited to the choice of set speeds but can open for whatever time is appropriate.

Some cameras also have a B setting, which allows you to keep the shutter open for as long as you like.

Shutter and aperture

The amount of light falling on the film can be governed by the size of the aperture or by the shutter speed. As both of these are usually arranged in similar steps (i.e. both shutter speeds and *f* numbers are arranged so that changing them by one setting either halves or doubles the amount of light entering the camera), a variety of combinations can be used to obtain the same exposure. For example, these combinations all give the same exposure time:

Aperture	Shutter speed
f2	1/1000 second
f2·8	1/500 second
f4	1/250 second
f5·6	1/125 second
f8	1/60 second
f11	1/30 second
f16	1/15 second
f22	1/8 second

The combination which you choose will depend on what speed is needed to catch the action and the aperture which is required to give sufficient depth of field. It is a question of balancing priorities. If you have established (by using an exposure meter – *see page 35*) that the picture you want needs an exposure of, say, 1/125 second at *f*5.6 then you could also choose to use the combination of 1/500 second at *f*2.8 if, for example, you were photographing a fast-moving object.

Your choice of aperture/ shutter speed combination controls the final result. The faster the shutter speed – the less blur. (Although remember this is not always an advantage. A moving

The fastest shutter speed is needed to catch rapid action such as this roundabout at a fairground. You need good lighting or a subject where the use of a wide aperture is possible.

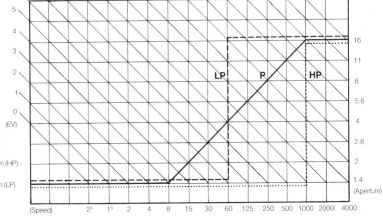

For most shots an exposure of 1/125th of a second is best – it will stop movement of the subjects and avoid camera shake.

object 'frozen' by using a very fast shutter speed can look unnatural.) The smaller the aperture the more of the photograph will be in focus – so this affects blur too, although this blur is not caused by movement but by part of the picture being out of focus. Again this can be used to great effect – blurring out unwanted details or fuzzy or ugly backgrounds.

Automatic exposure systems

The simplest automatic systems select a combination of aperture and shutter speed which is suitable for normal subjects. A system of this type will hold the lens open at full aperture until a speed of 1/60th is reached. This is a speed at which the camera can be held without danger of camera shake. After this as the light improves the aperture will be slowly closed and the shutter speed increased.

More advanced systems may have three or more programs or modes as they are called.

The most usual alternative programs are the high speed program and the wide program.

The high speed program selects the highest possible speed, which means that it combines this with a wide aperture. This is useful for taking sports shots or with a telephoto lens where there is a danger of camera shake. Because a large aperture is used, there is a shallow depth of field.

The wide program uses a small aperture to give greater depth of field and as a result it uses slow shutter speeds. This is called the wide program because it is often used with wide angle lenses.

This diagram shows the exposures chosen by a typical program. The diagonal lines indicate EV's – the value of the light. At EV14 on Normal program an exposure of 1/250th sec at f8 is shown; on High Speed Program the exposure is 1/1000th sec at f4; and on Wide Program the exposure is 1/60th sec at f16.

(F 1·4 lens: set at F 16)

——————— Normal program (P)

· · · · · · · · · · · · · High-speed program (HP)

– – – – – – – Low-speed program (LP)

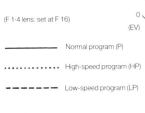

Using a tripod

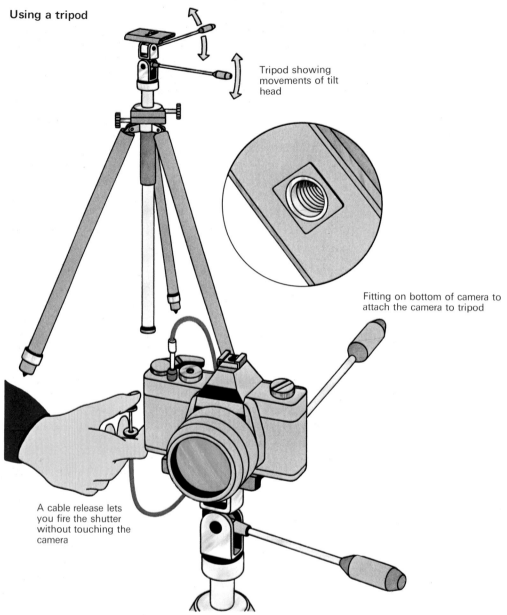

Tripod showing movements of tilt head

Fitting on bottom of camera to attach the camera to tripod

A cable release lets you fire the shutter without touching the camera

Tripods

When making exposures of longer than 1/30 second it is necessary to have a firm support for the camera as you won't be able to hold it steady for a long enough period.

On the base of most cameras is a tripod bush to enable it to be fixed to a tripod for long exposures.

Remember that the purpose of the tripod is to provide a steady support for the camera so do not buy the lightest available. A light tripod may be easy to carry but it will not be much use in supporting the camera. Some tripods have an extending centre column. This is useful but should not be extended more than 30 centimetres, or it will be unsteady.

Many modern tripods have pan and tilt heads which enable the camera to be tilted or turned to any angle.

For emergency use there are clamp tripods which can be fixed to gates or branches and have a tripod screw to fit into the camera. These can be helpful on occasions, but often there is not a gate or tree in the right position.

For general tips on how to hold your camera steady without using a tripod, *see page 54*.

When the camera is used on a tripod there is a danger of shaking it if the normal shutter release is used. To avoid this a cable release can be screwed into the shutter release button. This has a stout wire inside a casing, like a Bowden cable as used for a brake on a bicycle. A cable of 25 or 30 centimetres should be used.

Delayed action device

Some cameras have a delayed action device which operates the shutter about eight seconds after the shutter release is pressed, thus enabling the photographer to appear in his or her own picture.

Usually there is a lever on the front of the camera which is turned downwards to set the delay.

Film speeds

So far we have seen how being able to control the aperture and the shutter speed allows you control over the amount of light which enters the camera. The speed of film you use affects how much light *needs* to enter the camera to achieve a particular result.

Films are classified according to their speed which is usually expressed in the form of ASA (American Standards Association) numbers. These indicate the relative exposure which is necessary to produce a negative of given standard. The speed ratings are applicable where the films are processed according to the manufacturer's instructions. (The type of developer used can decrease or increase the effective speed of the film – *see page 122*).

The higher the ASA speed rating, the faster the film – that is, the faster it reacts to light, and therefore the less light it needs to produce a good result. So with a fast film a shorter exposure can be given.

Unfortunately speed in a film is secured at the expense of quality because different film speeds are achieved by varying the size of the silver halide grains on the film. Slow film has very fine grains, fast film large coarse grains. The large grains react more quickly to light, so fast films need less light than slow ones, but the large grains can show up in enlargements of pictures taken on fast film and spoil the result.

The speed of a film affects another quality besides grain size, and that is its ability to cope with high contrast – that is to record detail in both brightly lit and shadowed areas of a scene. Slow films cannot cope with detail in both the lightest and darkest part of a brightly lit scene.

Slow black and white films are those with ASA speeds of about 25-64. Medium speed black and white films for all round use are those with ASA speeds of about 100-200 and fast black and white films have speeds of ASA 400 and over.

In colour films only films for transparencies are available in

the range 25-64 ASA. Medium speed films for prints and slides have speeds of 100-200 ASA. There are high speed films of both types at speeds of 400 ASA and above.

ASA speeds are devised so that a film of twice the ASA speed of another is twice as sensitive. So a film of 250 ASA is twice as sensitive as one of 125 ASA.

Black and white film

Slow – 25-64 ASA: Slow films should be used when you want lots of detail in a scene without very high contrast. Unfortunately, owing to their slow speed, exposures have to be long and if the light is poor this means either using a large aperture or a slow shutter speed. A large aperture reduces the depth of field, so that the area sharply in focus is restricted; while a slow shutter speed increases the likelihood of camera shake which will spoil the effect. If slow film is used you must be prepared to take care in making the exposure to ensure that the results bring out the brilliance and fine detail of which the film is capable.

Medium – 100-200 ASA: Medium speed films are among the most popular. Their speed advantage over slow films means that on a bright sunny day an exposure of 1/500 second at *f8* can be used for action shots, while even on dull days an exposure of 1/125 second at *f5.6* will often be adequate. Thus they give the photographer scope to tackle most subjects. Although these films do not produce the exceptionally fine detail obtained with slow film, they can give very high quality results if prints no more than 203 × 254 millimetres are required. And medium speed films can be

Slow film gives detailed results.

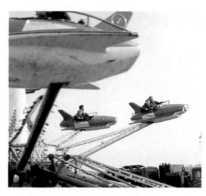

Medium speed film is able to cope with most speeds and lighting conditions.

used for a wide range of subjects. **Fast – 400 ASA and over:** The fast films enable hand-held shots to be taken in lighting conditions which are so poor that users of other films have to give long exposures using a tripod or other camera support – or miss the shot.

This high speed film is also useful for taking shots of sporting

High speed film enables you to use high shutter speeds in poor lighting conditions.

events, especially in dull weather. The speed is gained at the expense of grain size, so that if big enlargements are made the grain of the film will show up, especially in large areas of even tone, and the definition will not be as crisp as with slower films.

Ultra fast films (ASA 800 and over) are suitable for night photography and in very poor lighting conditions when you don't intend using a flash or other artificial lighting.

▷ If ordinary film is used for transparencies indoors with electric lighting the result will have an orange tinge.

▷ This orange tinge can be avoided by using tungsten film.

Colour film

As with black and white films there are slow, medium and fast varieties and the choice is similarly governed by the conditions in which the photographs are to be taken.

Nearly all colour films are made for use in daylight or with flash. If they are used in ordinary electric light (known as tungsten light) a filter (*see page 105*) should be used to avoid the orange-red tint these lights will otherwise give your photograph. If you are going to take a lot of photographs in ordinary electric lighting you can obtain a special *tungsten* film which compensates for the orange-red tint. This film can only be used for shots in tungsten light – used in ordinary daylight it gives a very bluish tint to the photograph.

Choice of film

You may well find that your choice of film is limited by the type of camera you have. Most simple cameras use film enclosed in a plastic case called a cartridge. Cartridge films are only made in two colour speeds – ASA 400 and ASA 100 – and one black and white speed – ASA 125.

35 mm and roll film for more sophisticated cameras is available in a much wider range of speeds. Always check with the instruction booklet to make sure you buy the right film for your camera and if in doubt ask at your local camera shop before buying.

Some cameras have a *film speed dial* which should be set to the number of the film you are using when you put the film into the camera. This dial could just be there to provide a reminder for you of what film you have put in

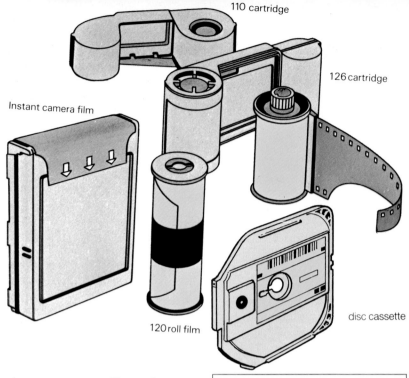

110 cartridge

126 cartridge

Instant camera film

35mm cassette

disc cassette

120 roll film

the camera – or if you have an automatic exposure meter it could actually influence the working of the meter. Either way it is important to set the film speed dial.

DX coding
Modern 35 mm film cassettes have small black and silver squares which are known as DX coding. These make contact with metal pins inside the camera and convey information as to the ASA speed and number of exposures on the film. This saves the photographer the task of setting the film speed on his camera. It also ensures that the camera is always correctly set for the film in it.

Read your camera instruction book. If your camera is not equipped to read DX codes, the film speed will have to be set on the dial. If a non-coded film is put in a camera with DX coding, the film speed will be set at 100 ASA whatever the speed of the film.

Shutter, aperture and film speed

As we have already seen, shutter speed and size of aperture can be used together to suit different conditions. The speed of the film you are using obviously affects your decisions about the aperture and shutter settings. When you buy a carton of film you will get a guide indicating the correct settings in different conditions.

Correct exposure

So far we have talked of light simply in terms of different weather conditions. Using a simple camera you may only need to judge whether it is very bright, bright or dull as these may be the only settings available to you. You may not even need to do this if your camera has no means of adjusting the shutter or aperture. With such a camera you need

Exposure guidelines for an ASA 64 film

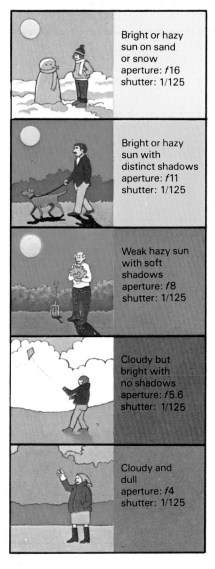

Bright or hazy sun on sand or snow
aperture: f16
shutter: 1/125

Bright or hazy sun with distinct shadows
aperture: f11
shutter: 1/125

Weak hazy sun with soft shadows
aperture: f8
shutter: 1/125

Cloudy but bright with no shadows
aperture: f5.6
shutter: 1/125

Cloudy and dull
aperture: f4
shutter: 1/125

good, bright light. But if you use a more sophisticated camera you will need a more sophisticated way of judging the amount of light available than by just glancing up at the sky, because the amount of light available will influence your shutter and aperture settings.

The guidelines given inside packets of film are good but there will be occasions when you will want an exact reading of what light is available and what settings are suited to these conditions. This is where exposure meters come in.

Exposure meters

Exposure (light) meters can either be built into a camera or be bought as a separate piece of equipment.

Modern meters use photoelectric cells. The original type, introduced in the 1920s, has a selenium cell. This acts as a battery which generates electricity when exposed to light. The current generated is used to move a needle which indicates the strength of the light. These meters are very accurate but have the failing that in very low lighting conditions very little current is generated and the meter needle may hardly move.

To overcome this the CdS (Cadmium Sulphide) meter was designed. This type of meter uses the fact that in complete darkness cadmium sulphide is an insulator, but it becomes a conductor when light falls on it. Current is applied from a small battery (which needs replacing periodically) and the change in the resistance of the CdS cell caused by the light is shown in the movement of the needle of the meter, thus giving a reading which can be converted into an exposure. This type of meter is more sensitive than the selenium cell type, but has the disadvantage that the cell has a lower response to blue light – a colour to which photographic emulsions are very sensitive – and it also has a much greater response to red than photographic materials.

Recently new types of meter have been devised to provide the instant reaction which is necessary in meters built into cameras. The first of these was the SPD (Silicon Photo Diode) in which there is a blue filter which brings the response nearer to that of photographic emulsions. This was followed by the GPD (Gallium Arsenic Phosphorous Photo Diode) which is said to be a thousand times quicker than CdS cells and is also not so sensitive to infra-red radiation and so gives a more realistic reading for photographic uses.

Meters in cameras

Nowadays very many cameras have some form of metering in the camera. As the amount of

Correctly exposed photographs should look bright, but not bleached, with good, deep colours and clear detail in the main areas. This viewfinder flashes up the aperture and shutter speed which the camera selects automatically.

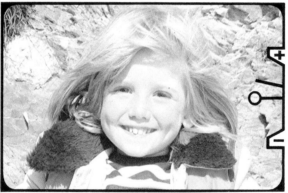

Overexposure produces a thin, weak result with a transparency. When using film from which prints are made, overexposure results in a dark negative and a pale print. This can be compensated for in printing, but the results will not be quite as good as a properly exposed photograph.

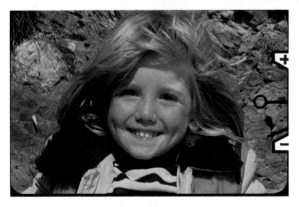

Underexposure produces a dark, dense result with a transparency. When using film from which prints are made, underexposure results in a thin, pale negative and a dark print. This can be compensated for in printing, but the results will not be quite as good as a properly exposed photograph.

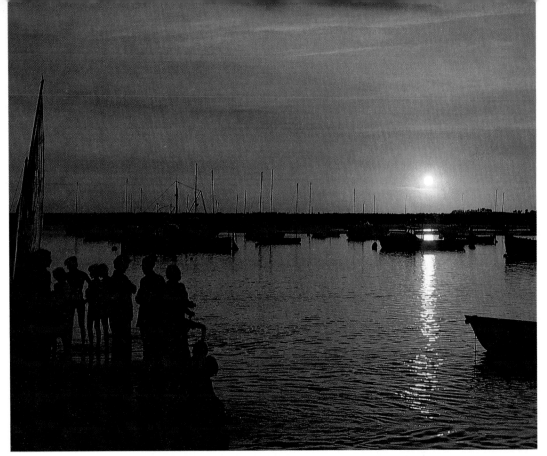

The rich colours of a sunset are always striking.

exposure needed is governed by two factors – the strength of the light on the subject you are taking *and* the speed of the film you are using – it is very important to remember to set the film speed dial on a fully automatic camera. If your camera is equipped to read DX codes the film speed will be set automatically.

On some models the exposure settings are made automatically and the photographer cannot control the selection. It may not seem important if you own such a camera to know what settings the camera will choose, however it is helpful to remember that when it is very dull the camera will select a slow shutter speed and a large aperture, so that it will not be possible to take rapidly moving objects or those where a great depth of field is needed.

There are also semi-automatic cameras where the light meter selects either the lens aperture or the shutter speed. On these you have to adjust either the aperture or the shutter to suit your requirements. The camera then sets the shutter speed or the aperture to suit the amount of light available.

Many cameras have an indication of the light meter reading in their viewfinder so you can conveniently see the reading as you view your chosen picture.

On some cameras light emitting diodes (LEDs) are used to display details of the exposure or to give warning of over or underexposure. Little figures or lights flash up in the viewfinder. Always check in the instruction booklet as to how the exposure meter displays its results.

It is useful to know with a camera which has a built-in exposure meter exactly how it measures the light. A good quality camera will measure the amount of light entering the lens but even this is not a foolproof way to achieve perfect results every time. Check in the instruction booklet to see if it tells you whether the meter measures light from all over the scene you want to photograph or just from the centre of it. Remember when making an exposure of a subject with a dark background the meter on the camera will give too much exposure; when making an exposure of a subject with a light background the meter on the camera will tend to underexpose. Many automatic cameras have an adjustment to allow you to change the aperture by one or two stops to allow for such conditions. And if not, you do have one variable factor you can control – the film speed dial. Trick the camera by altering the dial. If you 'pretend' to the camera that the film it contains is slower than it really is, it will allow more light to fall on the film, and vice versa if you 'pretend' the film is faster than it really is. This is not possible if your camera reads DX codes to set the film speed.

Even a very simple camera can be used to provide some flexibility. It may be very bright but you want to take a picture in the shade. Don't use the bright sun setting, use the symbol for dull or cloudy weather.

Once you really get accustomed to using your camera and checking the quality of your results you will be able to try experimenting like this more and more successfully.

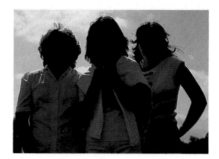

If you take portraits against the light, the meter will normally give a short exposure and the faces will be dark.

You can correct this problem with against the light shots by giving an increased exposure.

If your subject is in a different lighting from the camera, the result will probably be incorrectly exposed.

You can correct this problem by going up close and reading the exposure from the subject and using this reading to make your settings.

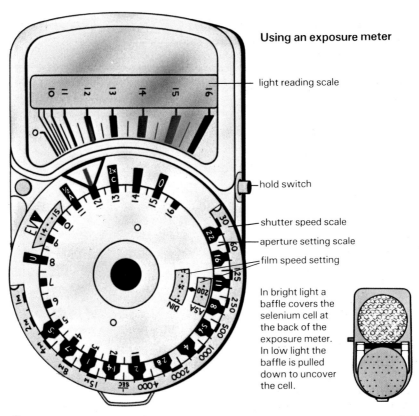

light reading scale

hold switch

shutter speed scale

aperture setting scale

film speed setting

In bright light a baffle covers the selenium cell at the back of the exposure meter. In low light the baffle is pulled down to uncover the cell.

Separate exposure meters

Some cameras have shutter speed and aperture controls but no built-in exposure meter to tell you how to set them. The instructions in the film packet will probably help you on most occasions but you might also want to buy a hand-held light meter for more accurate readings.

A separate exposure meter will have a window in which you must set the speed of film you are using and inside it will be a light sensitive cell which you must point at or hold near your subject. The needle will swing on the dial to show the light reading. This reading is set on a dial which will then indicate the shutter speed and aperture you should use. It will offer a choice so that you can decide which is more important to the picture – depth of field or a fast shutter speed.

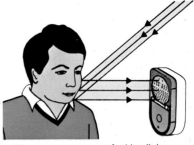

There are two ways of taking light readings – by pointing the meter at the subject to measure the light reflected from it or by holding it close to the subject to measure the light falling on it – a special cone is fitted to the meter for this purpose.

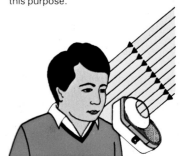

WHICH CAMERA?

Probably the most important consideration affecting your choice of camera will be price. But don't let price be the only consideration. Think very carefully before you buy a camera. If at all possible borrow a variety of cameras and try them out. Read the previous chapter – that will explain the workings of different parts of a camera and underline the difference between simple cameras, automatic cameras and adjustable cameras.

Look at what each sort of camera will and won't do in the light of what you want from a camera. The most expensive, most elaborate camera you can afford is not necessarily the best for you. Think what you will be using a camera for most of the time and take that very much into account. Do you want to take 'action' photographs of fast-moving sports? Then you want a camera with the option of a fast shutter speed. Do you want to take close-ups of flowers and insects? Then you want a camera to which you can fit a close-up lens. Do you want 'instant' results to show your family and friends? Perhaps a camera which gives instant prints will suit you.

Don't forget, before you make a final decision, that some camera dealers offer a range of second-hand cameras at reduced prices. It is worth considering these providing you buy from a reputable dealer and get some form of guarantee as to the camera's reliability. It really is not wise to buy a second-hand camera other-wise, as it could possibly be faulty and cameras are expensive and difficult to repair.

Before buying any sort of camera it is best to go to a good camera dealer, tell him what you want from a camera and ask his or her advice.

Modern camera types

Cameras are usually classified according to the size of film they use. This is convenient in some ways as film size controls the quality of the results to some extent, but it is not a very precise guide, because there are cameras of all degrees of sophistication using each size of film. Some 110 cameras are more advanced than some 35 mm models and there are several very cheap disc cameras.

Cartridge loading cameras

These are usually very small – the only cameras which can truly be said to be pocket models – although they should not be kept in pockets which are used to hold an assortment of other things.

In the previous chapter the term 'simple' camera was used to indicate a camera with very few controls. Most of the 110 and disc cartridge loading pocket cameras come into this category.

Cartridge film is easy to load because it is packaged in instant-loading plastic cartridges, and in most cases there are keys on the

Disc Camera

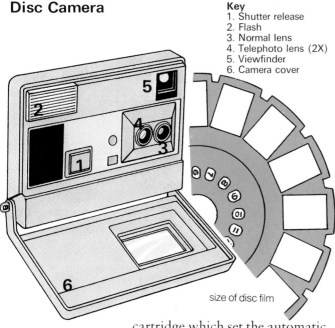

Key
1. Shutter release
2. Flash
3. Normal lens
4. Telephoto lens (2X)
5. Viewfinder
6. Camera cover

size of disc film

cartridge which set the automatic exposure system, if the camera has one, for the speed of film used.

It is difficult to produce high-quality large prints with 110 and disc cameras because their small size and weight means that it is hard to hold them steady and that the small negatives have to be considerably enlarged to make prints. However, good models will produce attractive enprints and modest enlargements.

Disc cameras use a form of negative different from all other cameras. The negatives are not in a continuous roll but are arranged singly round the edge of a disc.

The pocket 110 camera uses film 16 millimetres wide on which it produces negatives 17 × 13 millimetres. (The difference between the width of the film and the width of the negative is because the negative has a small border around it.)

Smaller film size does not make for a lower cost per shot. In most cases a 20 exposure cartridge of 110 or disc film costs less than a 20 exposure cassette of 35 mm film, but if a 36 exposure cassette of 35 mm is bought, the cost per negative is less than that of individual shots on the 20 exposure 110 and disc cartridge. There is usually no difference in the cost of processing.

An important point to be considered if you are thinking of doing your own developing and printing is that the small size of 110 and disc negative makes this difficult and there is not a great choice of equipment. However, if you intend having your work trade processed and want a camera which you can easily carry about with you, this size makes a very useful start.

The simple 110 and disc pocket cameras usually have direct vision viewfinders – which means parallax error (*see page 17*) can be a problem with subjects at close distances. Most have fixed focus lenses which means you cannot alter the focusing but, owing to the short focal length and small aperture, everything from about 1·5 metres is in focus. Some have a limited degree of focusing control – for example, a camera may have focusing settings for portraits, groups and landscapes.

As a general rule these simple cameras are not suitable for close-up work because it is not possible to fit close-up lenses on most cheap models. If taking close-ups is an important part of photography to you, it is worth thinking carefully about this point before buying.

Some 110 cameras have a second, built-in lens which can be switched over the main one, enlarging the image by 50 to 60

110 Camera

Key
1. Shutter release
2. Flash and weather symbols
3. Flash cube socket
4. Lens
5. Viewfinder

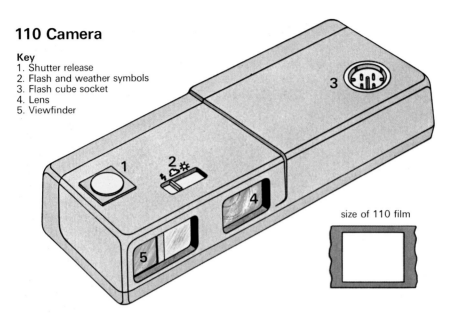

size of 110 film

per cent. This second lens has the effect of bringing the subject closer and so is useful for shots of distant objects where it is impossible to walk in closer.

Control over the shutter and aperture on all the cheapest pocket cameras will, if there is any at all, be limited to a choice of weather symbols. As the choice of aperture and shutter speed is so limited there is no real need for accurate exposure metering. This limits the owner of a simple camera – you cannot photograph fast moving objects by choosing a fast shutter speed or use the camera in poor light without a flash.

These simple cameras will have fittings for flash cubes or some form of electronic flash unit. Some models will have a built-in flash.

The choice of film in terms of speed will probably be limited, but black and white, colour negative and colour transparency film is available in speeds suitable for most normal lighting conditions.

Having read the above, the

owner of a simple camera may feel disheartened, but he or she shouldn't be. The owner of a simple camera should never look down on it. Every camera is merely a simple model with some additions. For most subjects the standard lens and a normal exposure are what is required, so whatever outfit is owned, the picture will be taken the same way.

The essential parts of a camera are the viewfinder and the lens. The viewfinder should give a good clear picture and the lens should reproduce the scene sharply. Many simple cameras score well on these points. The bright line type of viewfinder fitted to many of them is a joy to use. For most subjects a fixed aperture of about $f8$ is adequate and there are few lenses that will not perform well at that aperture.

The user of a simple camera will have the advantage that it is quicker to operate because there are less adjustments to make.

The simple camera will cope with the majority of pictures and if you do not require very large

prints, the difference between the results obtained with a basic camera and those from a more expensive outfit will be hardly noticeable.

Except for the chapters dealing with special equipment the ideas in this book for developing your photographic skills can all be tried by the owner of a simple camera with few or no controls.

35 mm cameras

35 mm film is 35 millimetres wide, producing negatives 24 × 36 millimetres. The reason for the rather confusing difference between the width of the actual film (35 millimetres) and the width of the negative (24 millimetres) is that the perforated border takes up the difference. The film comes in cassette form, and is available as colour negative, colour transparency and black and white film with a wide variety of speeds also being available.

35 mm cameras are used by many serious amateurs and professionals. The negatives from good cameras with top grade lenses can be enlarged to 40·6 × 50·8 centimetres or more if required and 35 mm transparencies are the standard size for projecting, so they can be shown anywhere.

For the photographer who is going to take the hobby seriously there is the advantage that this size of film can be conveniently handled in the darkroom.

35 mm cameras usually allow more choice of shutter speed and lens aperture than is possible with 110 cameras. Even the simplest 35 mm camera will accept close-up lenses, filters and other accessories (see page 111 onwards),

but these facilities are not easily available for many cartridge loading cameras.

This size of camera is certainly a good all round choice.

35 mm compact camera

The 35 mm compact non-reflex camera is one of the most useful types of camera. As its name suggests it is smaller than the normal 35 mm camera, although it is large compared with most 110 cameras.

Unlike the 35 mm single lens reflex (SLR) camera, these 35 mm cameras do not have an arrangement whereby what you see through the viewfinder is the image passing through the lens. These simpler cameras rely on direct vision viewfinders (see page 16). When coupled with a rangefinder this direct vision viewfinder is a perfectly adequate arrangement, and allows for adjustable focusing.

Nearly every model has some form of automatic exposure control. Most of the higher priced 35 mm compacts have automatic focusing. Many also have motor wind which usually also rewinds the exposed film.

The lens fitted to this type of camera is usually of higher quality than those fitted to the simpler cameras and very good results may be obtained. Some 35 mm compacts have a device which increases the focal length of the lens at the touch of a switch. This gives the benefit of a telephoto lens.

Different makes have differing degrees of control over the aperture and shutter but most will offer a more satisfactory range of adjustment than an ordinary pocket camera.

The negatives are larger than

35 mm Compact Camera

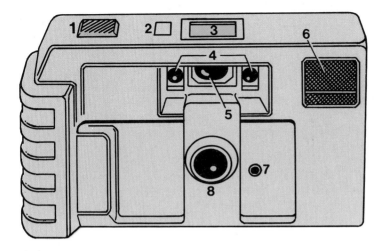

KEY
1. Shutter release
2. Mode selector switch
3. LCD information display
4. Autofocus sensors
5. Viewfinder
6. Flash unit
7. Light sensor for auto exposure
8. Lens

size of 35 mm film

those produced by the 110 cameras and can therefore be enlarged more easily and successfully.

Some very cheap 35 mm non-reflex cameras are now available costing very little more (or even in some cases less) than the simple pocket camera. If you are thinking about developing your interest in photography look carefully at the 35 mm compact non-reflex cameras. They are a very good buy for a beginner who wants rather more than a simple 110 camera can offer.

There are some very expensive 35 mm non-reflex cameras. This class of camera includes the *Leica* which has always been regarded as being a leader for quality. In order that the lenses can be changed these cameras have focal plane shutters. This means the shutter is not inside the lens, but just in front of the film, and so lenses can be changed in mid-film without the film being exposed to the light.

These cameras are among the most expensive and are used by professionals and the press.

35 mm SLR camera

The 35 mm single lens reflex (SLR) camera is one of the most versatile types and, with a wide range of interchangeable lenses available, can be used as conveniently for taking telephoto shots of sports events as for close-ups of flowers.

The view seen in the viewfinder is that seen through the taking lens, so the user sees what will appear on the film. The use of a pentaprism produces a brilliant right way round right way up view in the eyepiece. This type of viewing eliminates the problem of parallax and is especially useful when taking close-ups.

Many SLR cameras have additional help with focusing – the ground glass screen on which the image is focused having either a split-image or microprism focusing aid (*see page 21*). Some 35 mm SLR cameras are now fitted with automatic focusing.

On most 35 mm SLRs the lens can be removed and others, from wide-angle to telephoto, substituted (*see page 111*) with the

great benefit that the viewfinder always shows exactly the view presented by the lens. For close-up work various attachments (*see page 114*) allow the camera to be used to take the smallest objects at full size on the film.

The modern SLR camera usually incorporates 'through the lens' (TTL) built-in exposure metering, in which the light reading is based on the actual picture area. And it means that the amount of light entering the camera when different lenses and attachments are used can be accurately assessed by the camera's exposure meter.

All SLRs will have a good range of aperture and shutter settings. In fact this type of camera can tackle almost any subject if the right lens and other accessories are purchased – *but* these may cost as much as or more than the basic camera.

Automatic setting: A great many cameras now make settings automatically which previously the photographer had to set. Some modern SLRs have auto-matic expsure programs. Other modern cameras have built-in exposure meters which may either indicate the amount of light and leave the photographer to adjust the shutter and aperture accordingly, or may automatically adjust the shutter and/or the aperture. The *shutter-preferred* system means you must set the shutter speed but the aperture size is automatically selected.

With *aperture-preferred* cameras you select the aperture and the exposure metering system selects the shutter speed.

When choosing a camera you must decide for yourself what automatic features, if any, you would like. Some people prefer the camera to do most of the work, while others like to decide for themselves.

An ideal situation seems to be those cameras which give you a choice – you can either set the camera to control the shutter and aperture automatically or you can set them yourself. However, these cameras are only found in the more expensive ranges.

SLR Camera

KEY
1. Shutter release
2. Motor mode control
3. Shutter speed controls (in manual)
4. Mode selector
5. Exposure Memory Lock
6. Hot shoe for flash gun
7. Self Timer
8. Film speed setting control
9. LCD Information panel
10. Aperture Scale
11. Depth of field scale
12. Focusing scale
13. Lens
14. Lens release lever
15. Self timer indicator light

size of 35 mm film

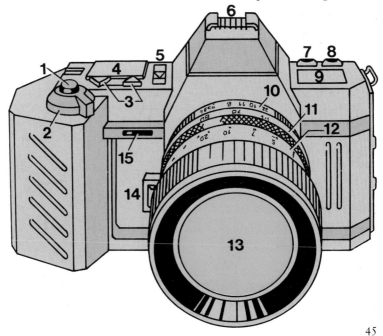

120 roll film cameras

This size of camera was at one time the most popular and many homes still have an old 120 Box Brownie which was bought in the 1950s or even earlier.

Now however, apart from one or two cheap imported models, the range of 120 roll film cameras available is among the more costly and their use is mainly restricted to professionals requiring the high quality which a larger negative brings. These are superb cameras and are ideal for experts.

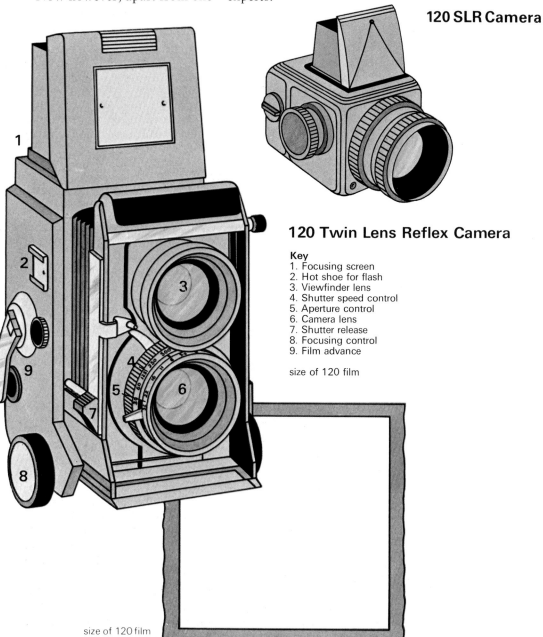

120 SLR Camera

120 Twin Lens Reflex Camera

Key
1. Focusing screen
2. Hot shoe for flash
3. Viewfinder lens
4. Shutter speed control
5. Aperture control
6. Camera lens
7. Shutter release
8. Focusing control
9. Film advance

size of 120 film

size of 120 film

120 SLR camera

The modern 35 mm camera will produce work which satisfies most requirements. However, other things being equal, a larger negative size will produce results of a higher quality which can be enlarged to a greater size.

For special results, especially in colour, a camera using 120 roll film is sometimes preferred. These produce negatives of 6 × 6 centimetres or 6 × 7 centimetres. Such cameras can have a means of masking the negative to make it smaller, so that more exposures can be made on one film.

These cameras are usually very expensive, costing several times as much as the average 35 mm SLR.

Most of the 120 reflex cameras are of simple box formation with a lens at the front and a screen on which the image can be seen on the top.

This was the type of camera taken on the moon walk.

120 twin lens reflex camera

This is one of the oldest established types of cameras. Although this type of camera was highly regarded at one time, there are now very few on sale.

As explained on *page 18* the twin lens reflex (TLR) has two lenses of identical focal length. One is used to view the image, the other to actually take the picture. Parallax error is caused by the slightly differing viewpoints of the two lenses, which can be a problem.

The focusing screen is at the top of the camera and shows a full-size picture. It does have the disadvantage that the image appears reversed. Unlike most other cameras you usually look down on the focusing screen of the TLR rather than into a viewfinder eyepiece.

Most TLRs have a good range of shutter and aperture settings and can be fitted with some form of flash.

As far as interchangeable lenses go, some TLRs allow this, but there is the problem that two lenses must be purchased.

Large format cameras

For work in professional studios, especially for producing photographs where the highest quality is required, large cameras taking negatives up to 165 × 216 millimetres or 203 × 254 millimetres are used. These are similar to the cameras used at the turn of the century, except that they are usually made of metal instead of the beautifully finished wood of early cameras. Cameras of this type use individual sheets of film instead of rolls.

Instant cameras

There is a range of instant cameras from simple snapshot models to single lens reflex types. These all provide a finished colour print within a few minutes of making the exposure. On cheaper models the print is removed manually, while on the more expensive versions a motor ejects the print. The prints are in the region of 8 × 8 centimetres.

All types of instant cameras have some form of exposure control which usually produces a correctly exposed print. Some have an automatic exposure control and a lighten/darken control allowing the photographer to have some say in the result. Most

Instant Camera

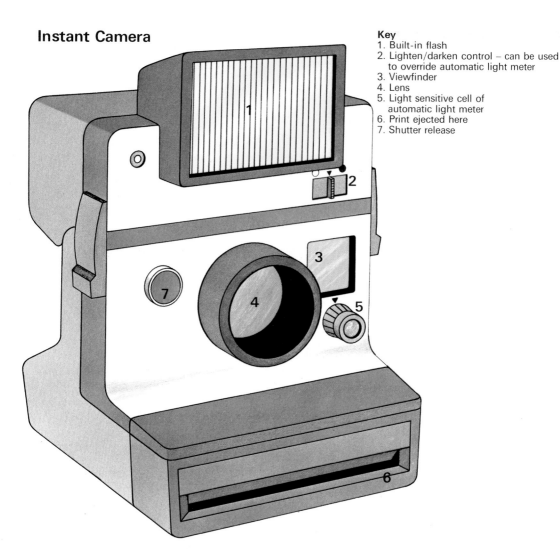

Key
1. Built-in flash
2. Lighten/darken control – can be used to override automatic light meter
3. Viewfinder
4. Lens
5. Light sensitive cell of automatic light meter
6. Print ejected here
7. Shutter release

models will have scope to use some sort of electric flash unit.

For those occasions where someone says: 'I'd like a picture of that' – perhaps their garden, a child playing with a dog, or some other incident for which only one print is required – they are ideal.

Instant photography is also helpful for those trying to improve their photography, for it is possible to see how a scene looks in a print immediately, so that the result can be compared with the original scene and a second picture taken if you are not satisfied with the result.

Professional photographers sometimes use instant cameras to check the lighting and composition before going on to use their sophisticated adjustable cameras.

Some models of instant cameras are very cheap to buy, but the packs of sensitive material are costly, so that prints are more expensive than those produced by normal processes. Obviously you do not have a negative but it is possible to get a picture copied and even enlarged.

WHICH CAMERA: SUMMARY

Type	Compact 35 mm	35 mm SLR	120 SLR	Instant
Simple cartridge 110 or Disc				
Cost	Moderately priced	Most cameras of this type are expensive	Very expensive	Reasonably priced but film costs are high – although this includes one print.
Usually the cheapest to buy – film and processing costs about the same as 35 mm				
Special advantages	Good for most subjects and light to carry	Through the lens viewing ensures accurate framing of shot	Gives high quality enlargements	Prints available straightaway
Very simple to use and light to carry				
Most suited for	General shots of people and scenes – good all-round camera	Most subjects: interchangeable lenses allow for close-ups and telephoto shots	High quality large prints but can tackle most subjects if suitable lens used	General shots of people, animals etc.
Static subjects in good light – people, scenery, etc.				
Least suited for	Studio work	Studio work	Family snaps	Close-ups, action, distant scenes
Close-ups, action, distant scenes				
Exposure control	Some manual – most automatic	Manual and automatic models available – often with choice of system	Usually manual – some models have provision for automation	Most are fully automatic
Usually fully automatic				
Focusing	Scale or range-finder – some automatic	Usually split-image/microprism – some automatic	Ground glass screen to focus on	Some fixed, some automatic
Usually fixed				
Attachments	Flash, full range of filters, close-up lenses	Flash, full range of filters, alternative lenses	Flash, full range of filters, alternative lenses	Flash, little else available
Flash, little else available				

READY, STEADY, GO

You've got a camera, you've read its instruction booklet and the previous chapters, so you know exactly what it will and won't do and why – now you are ready to load it with film and start taking pictures.

Loading

Although the films used in amateur cameras are in light-tight packings it is best to load and unload the camera in a shady position to avoid any chance of some frames being 'fogged' by light reaching them.

The loading procedure varies with individual cameras and it is essential to read the instruction book carefully and to memorize the procedure.

Making the exposure

To take successful photographs you have to be able to handle your camera automatically. This comes from much practice. Make sure you know which ring to turn to change the aperture and which to focus. Find a good way to hold the camera, and get the feel of the shutter release so that when you press it down you know exactly the moment it will operate.

More exposures are spoiled by moving the camera than by anything else. Often this is because the photographer has not found the best way of holding his camera.

Loading the camera

1. Only open the camera in a clean, dust (and sand) free place.

2. To avoid mixing the exposed film with the unused one, put the exposed film safely out of the way in a camera case or your pocket before opening the new carton of film.

3. While the camera is open make sure there is no dust inside. Any dust particles or fluff should be removed with a small dry soft brush.

4. When closing the camera back, make sure that the fastening clip is securely niched home.

5. Follow the directions as to winding on the film for the first exposure.

6. Set the film speed dial if your camera has one.

Loading a Disc Camera

A

Loading a 110 Camera

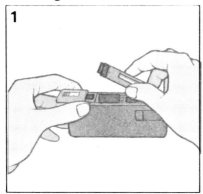

1

Load and unload the camera out of direct sunlight. Open the back of the camera carefully.

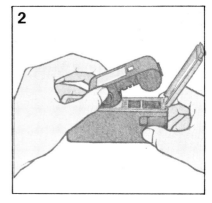

2

Put in the cartridge. One side of the spool is larger than the other so if the cartridge doesn't slide in easily try it the other way round.

A
Open the back of the camera in darkened room. Release securing clip to open back.

B
Insert film cartridge, ensuring it is correctly positioned with central spindle engaged.

C
Close back of camera with securing clip in open position. When clip is closed, the film will automatically wind on to frame one.

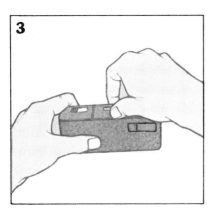

3

When the cartridge is in position, push it down gently to make sure it is quite flat before closing the back of the camera. Make sure the back is firmly shut.

4

Operate the film advance until the figure 1 appears in the exposure counter. The camera is now ready for you to start taking pictures. When the final exposure has been made keep winding the film on until it stops. Then you can take the cartridge out.

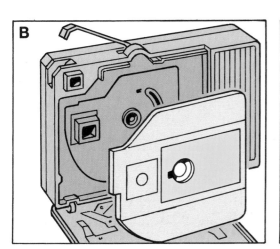

B

C

Loading a 35mm Camera

Load and unload the camera out of direct sunlight. Open the back of the camera by pulling up the rewind knob or by pulling down the rear coverclock.

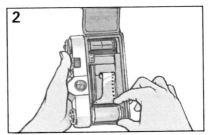

Insert the cassette of film in the chamber beneath the rewind knob. When it is in place, push down the rewind knob and turn it until it clicks home.

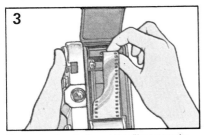

Fix the leading trailer of the film securely into the slit in the take-up spool, making sure the bottom line of sprocket holes is over the sprocket.

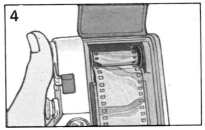

Wind on the film by alternately pressing the shutter release button and moving the rewind lever until both the top and bottom lines of sprocket holes are engaged.

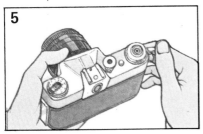

Close back of camera and continue winding on until the figure 1 appears in the exposure counter. Remember to set the film speed dial. When the film has been completely exposed it must be wound back into the cassette.

To rewind the film press the rewind button and raise the rewind crank. Rewind until you notice a change in tension. Now you can take the film out of the camera.

With a 110 camera it is especially necessary to avoid camera shake because the tiny negatives have to be enlarged many times in making the prints.

Fit the camera into your hands while still allowing the right forefinger to gently operate the shutter release. Standing with the legs slightly apart can help.

With a 35 mm camera which has to be focused it is usually easier to grasp the camera with the right hand with the thumb behind the body and the forefinger on the shutter release, and the three other fingers on the front of the camera. The left hand then curls round the lens mount holding the focusing ring so that

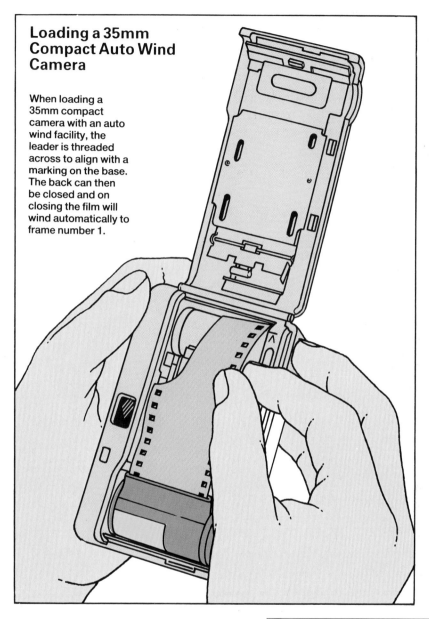

Loading a 35mm Compact Auto Wind Camera

When loading a 35mm compact camera with an auto wind facility, the leader is threaded across to align with a marking on the base. The back can then be closed and on closing the film will wind automatically to frame number 1.

adjustments can be made. In this position it makes a cradle for the camera.

Using a fast shutter speed helps to reduce camera shake. It has been suggested that out of all shots taken at 1/15 second, 50% show camera shake; at 1/30 second, 25% show shake; at 1/60 second, 12%; at 1/125 second, 6%; and at 1/250, 3%.

Sharp results

One of the most appreciated qualities in a photograph is sharpness. It can be recognized by everyone, and when it shows up detail which the eye does not usually notice it attracts instant attention.

Sharpness in a photograph is

How to hold your camera

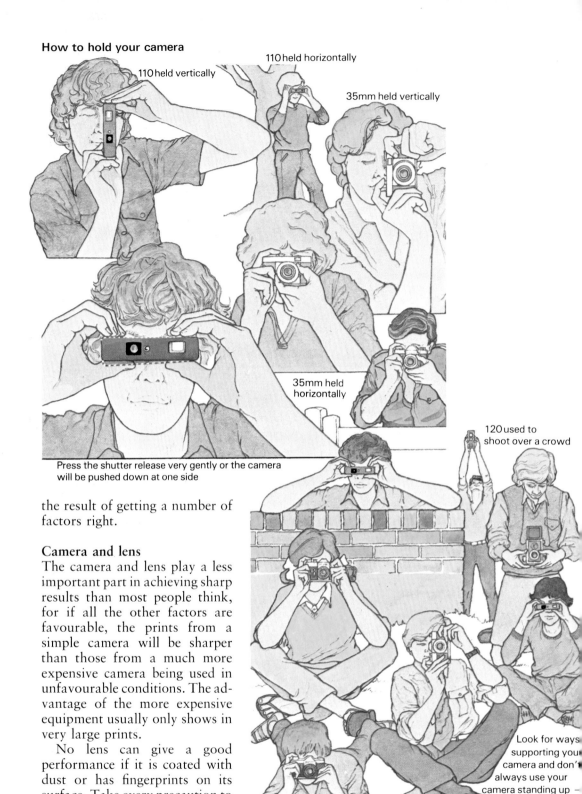

110 held vertically

110 held horizontally

35mm held vertically

35mm held horizontally

Press the shutter release very gently or the camera will be pushed down at one side

120 used to shoot over a crowd

Look for ways supporting your camera and don't always use your camera standing up – try sitting, kneeling or lying down.

the result of getting a number of factors right.

Camera and lens

The camera and lens play a less important part in achieving sharp results than most people think, for if all the other factors are favourable, the prints from a simple camera will be sharper than those from a much more expensive camera being used in unfavourable conditions. The advantage of the more expensive equipment usually only shows in very large prints.

No lens can give a good performance if it is coated with dust or has fingerprints on its surface. Take every precaution to protect your lens. Keep a lens cap

on whenever possible and *never* touch the surface with a finger. If the lens does get dusty, clean it gently with a soft lens brush. Remove fingerprints with lens cleaning fluid.

Aperture

If you have a camera with an adjustable aperture remember that all lenses give greater sharpness when stopped down one or two stops below their maximum aperture. At *f8* or *f11* almost any lens will give sharp results and the resulting increased depth of field will help to produce all-over crispness.

Focusing

With subjects close to the camera careful focusing is essential. Make sure that you have enough depth of field to cover the subject. If it is not possible to cover the whole of the subject it is preferable to have the foreground sharp and to allow the loss of a little detail in the more distant part of the picture.

Shutter speed

The higher the shutter speed the more chance there is of getting sharp results, for this helps to cope with the problem of movement – of the subject and of the camera.

Subject movement is not only a problem when taking action shots, but it can also spoil pictures of flowers and other delicate subjects which are often blown by the wind. A shutter speed of 1/125 second or 1/250 second should be used whenever conditions permit.

Steady camera

Even the best camera will not give sharp results if it is not held steadily. Practise until you are sure that every shot is shake-free.

Film

For recording detail, the rule is to use the slowest film possible. Speed in a film is gained at the expense of grain size. The faster the film, the larger the grain. However, if using a slow film makes it necessary to give a long exposure, the expected gain in sharpness may be lost by camera shake.

Subject

Don't expect your camera to produce a bitingly sharp picture of a subject which has no sharp edges. A view across the countryside on a misty morning has no sharp detail to record.

Lighting

Lighting plays a vital part in achieving sharpness. Bright sunlight or light from a flash gun brings out the details and colour of a subject, but dull hazy lighting will only produce a dull hazy result. Light makes the picture and without it results cannot be sparkling.

The angle of the lighting is also important. Flat frontal lighting will produce flat results. With strong side lighting detail stands out with biting sharpness and the texture of stone and other rough surfaces is brought out.

Processing

Having taken the photograph there is nothing that can be done to improve a blurred image, but there is opportunity to spoil a good one! If you have your films processed by a dealer find a reliable firm that cares about the results. If you process your own films pick a developer that makes

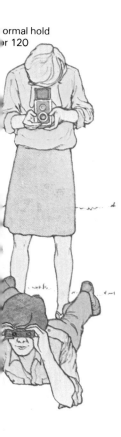

ormal hold
or 120

sharp negatives and take as much care as you did in making the exposure.

Look at the results

Of course you look at your photographs when they come back from the dealer or when you've developed them. But look at them critically. Analyse what is good and what is bad about them.

If you are really keen to improve your photography, keep a notebook recording what conditions pictures were taken in and what settings you chose to use. When possible take the same shot using different settings. Decide which result you like best and remember how you achieved it.

A picture taken on a misty day (like the one opposite) can't give a sharp result like the subject shown left.

CAMERA CARE

Even the cheapest camera is a complicated and delicate instrument and should be handled with great care. A camera breakdown may mean that you lose a picture which you specially want.

RULE 1
Read the instruction book so that you don't use the controls wrongly, which may strain some important part of the camera.

RULE 2
Carry your camera in a case to protect it from knocks, dust and rain. Always put the camera in its case somewhere safe. Don't leave it in the sun where it may get overheated and don't put it down on the sand on the beach.

RULE 3
When using the camera have it on a neck strap if possible. This will help you to avoid dropping the camera and also prevent you from putting it down where it may get damaged.

RULE 4
Never touch the lens. Keep it covered with a lens cap except when actually taking a picture.

RULE 5
The mechanism inside a camera is very small, so the controls should be operated gently. If they appear to be stiff, check with the instruction book. You may have forgotten the correct sequence.

RULE 6
If your camera has a battery, note the date it was fitted and change it after one year. If there is a battery checking device use this if in doubt about the power.

CHECK BEFORE YOU SNAP!

1 Before starting out make sure that your camera is loaded with film and the film speed dial (if you have one) is set for the film you are using.

2 Make sure the film has been wound on.

3 Always study your subject in the viewfinder. Make sure no unwanted objects are included. Get the main subject as large as possible.

4 Check that the lighting is suitable for the subject and does not make unpleasant shadows. Make sure that the sun is not shining into the camera lens.

5 If you have a non-focusing camera check that the subject is not too near the camera. On a focusing camera check that the lens is focused on the main subject.

6 Except on fully automatic cameras select an aperture which gives sufficient depth of field and allows a suitable shutter speed.

7 Set a shutter speed suitable for the subject. Use at least 1/125 second if possible, to avoid camera shake.

8 Check that the lens and meter window are not obscured. Possible culprits are: the lens cap, the slide cover, your fingers, your hair, the camera strap and the case flap.

9 Give a last quick check to make sure that the pose is suitable and that the lighting is still right and no unwanted objects have strayed into the picture.

10 Press the shutter release slowly . . . And practise so you can do all this without stopping to think!

LIGHT

Photography is drawing with light. Without light there can be no pictures. Light makes shadows and these give interest and form to objects. In poor light colours are dull. Study the effects of light and you will see many ideas for pictures.

The best source of light for photography is the sun. It costs nothing and it creates effects on a grand scale. Some flash guns produce more intense light, but it is strictly limited. You could not light a landscape with a flash gun.

Sunlight produces different effects in different weather conditions and at different times of the day. What is known as the 'colour temperature' of light varies. At dawn and at sunset the light often has a pinkish tinge. The harsh light at midday can have a bluish tinge. You can compensate for these variations with filters but often it is most effective to use the changes in the quality of light to give extra atmosphere to your pictures.

Angle of lighting

The angle of lighting on a subject has a considerable effect on the success of a photograph. This is especially important in the case of black and white pictures which rely upon the contrast between light and shade for their effect. In colour work, different considerations apply because colour film is not able to cope with wide differences of lighting and if the shadows are too dense they will be shown as solid black areas.

Choose a fixed object or scene to photograph and look at it at different times of day. This way

◁ The same scene taken in the morning and at lunchtime. See how the lighting has moved round and brings out the distant buildings.

◁ With and without sun. See how much difference bright sunlight makes to a picture.

▷ The pink light of early morning adds attraction to this shot of a lake. The film exaggerates the effect.

△ Colour film emphasizes the rich, reddish light of this harbour scene in the evening.

you will be able to study the effect of different angles of lighting.

Flat lighting (front light)

Standing with the sun on your back and looking straight at a scene, everything will be well lit and there will be no deep shadows. This is a favourite lighting for colour work because it gives a good strong colour with no deep shadows. It is most suitable for scenes which have plenty of colour, such as a bright seaside snap.

Front lighting is not very successful for black and white photography because the absence of shadows means that there is nothing to indicate shape – especially the shape of curved objects.

45% lighting

Look at a scene when the sun is at an angle of approximately 45% to your back. You will see that the scene looks much more interesting, with shadows showing the shape of things and making them stand out from one another. This 'sun over your shoulder' lighting is a favourite with photographers using black and white film. It needs using with care when taking shots on colour film, for colour film is not able to cope with an extreme contrast between highlights and dense, dark shadows, so the latter become very dark, especially on transparencies.

Shadows often receive a certain amount of reflected light. This can be a help in black and white work; in colour, however, the reflected light may be coloured, so that a person standing beside a green hedge may have the shadow side of his face tinged with green.

90% lighting

With the sun at your side so that it is shining directly across the scene, the texture of subjects shows up strongly. This is good lighting to show the roughness of stonework, the pebbles on the beach or other similar subjects. You would not choose it for taking a flattering portrait because it would bring out every blemish on the subject's face.

A disadvantage of 90% lighting is that shadows can be thrown across the picture and if there are trees, for instance, they will throw dark lines across the picture which will divide it into

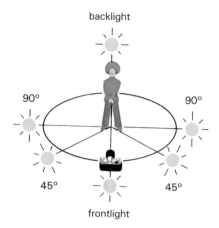

Angle of lighting

backlight

90° 90°

45° 45°

frontlight

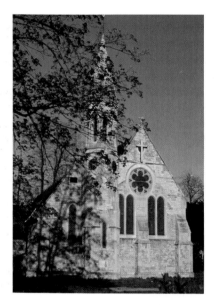

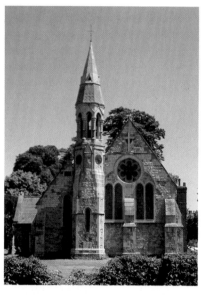

▽ 90° lighting – shows the texture of the stone.

▽ Back lighting – shows the subject in silhouette.

△ Front lighting – brings out the colour of the subject, but the absence of shadows means that there is nothing to indicate the form.

▷ 45° lighting – shadows show the shape of the tower and buttresses.

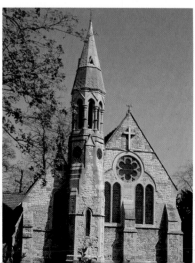

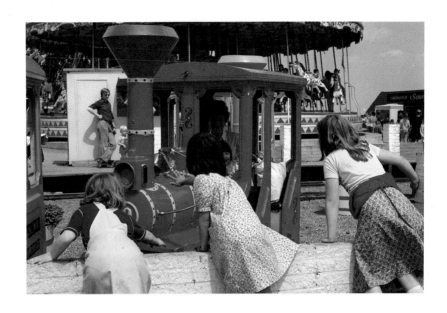

▷ Flat lighting brings out the full colour of a subject.

▷ Side lighting (45°) brings out the detail of stonework and carvings, giving roundness to objects.

▽ 90° lighting gives a striking effect over this ploughed field.

▷ Shooting into the light produces delightful effects – especially over water.

strips. On the other hand this effect can be used intentionally to produce a striking result.

Against the light (back light)
Look at a scene when you are facing directly into the sun. This lighting gives a dramatic view, especially if the sun is not too high. The subject will stand out against the light. (For more about this type of lighting *see page 78*).

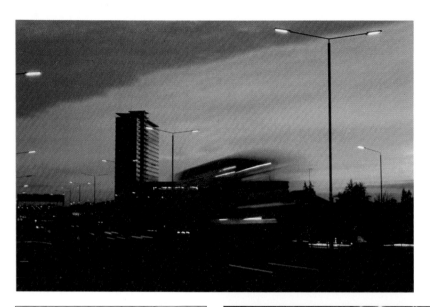

Near sunset lights show up well.

Available light

Available light is a term used for shooting in poor lighting conditions without using extra lighting such as flash. This often produces most interesting results.

The secret of taking available light pictures is to make the very best use of what light there is. You will see that light glints on wet or polished surfaces and brings out shapes and patterns. This effect is usually seen best with the light well to the side or even behind the subject. The results have a special quality of mystery.

This type of shot is often better

Subject	Shutter speed	Aperture
Brightly lit streets	1/4-1 second	f8
Other lit streets	2-4 seconds	f8
Floodlit buildings	1-4 seconds	f8
Bright shop windows	1/15-1/2 second	f8
Camp fires (close to)	1/8-1 second	f8

Experiment using this guide and a fast ASA 400 film.

in black and white because there will be little colour in the scene. However, don't let the opportunity go by if your camera is loaded with colour film. You will often find that the results have strange colours which add interest.

Night photography using the light from street lamps, buildings and cars is a special form of available light photography. The best time to take these shots is at dusk when there is still a little light in the sky. Then the film will be able to record the shape of the buildings and enough detail to make the pictures look more

△ Look in shop windows for interesting available light pictures.

◁ A wide range of exposures will catch electric signs.

▷ A shaft of sunlight can be used to produce an unusual and striking shot.

interesting than those taken later when the sky is quite dark.

Cameras with automatic exposure systems do not cope very well with night photography. If your camera can be used on 'manual' it is better to use this and to set the exposures yourself.

Don't be too worried about the problem of estimating the exposure. Quite a short exposure is sufficient to record the light and even several minutes' exposure will not record the detail of the buildings. The best results come with exposures which show the lights well and give a shadowy outline of the buildings.

The amount of light in this sort of subject varies considerably but after some experiments you will be able to judge the exposure needed. It is a good idea to take shots giving two and four times the suggested exposures to see the effect they produce. For these long exposures the camera will have to be put on a tripod or some other form of support and there is little advantage in opening the lens to a large aperture. Using an aperture of *f*8 gives added depth of field and reduces the need for accurate focusing which is difficult in poor light.

Artificial light

To a photographer, artificial light means the tungsten electric lighting used in most houses. If a shot is taken in this light with a normal daylight type colour film, the result will have a yellow tinge. A filter (*see page 105*) can be used to correct this, but this reduces the speed of the film. For this reason most indoor colour shots are taken with flash, which provides a light very similar to daylight.

Another alternative is the use of tungsten film for indoor colour shots. This film is specially prepared to compensate for the yellow tinge produced on photographs taken on ordinary colour film in artificial light (*see page 33*). However, this type of film can be difficult to obtain.

Black and white shots can be taken with no trouble in tungsten lighting. However, ordinary household bulbs give a very low-powered light for photography and long exposures are needed. If much photography is done by artificial light the bulbs can be replaced with Photoflood bulbs which give a brighter than normal light – a No. 1 Photoflood bulb uses 275 watts but gives the equivalent of 800 watts. This is achieved by overrunning the bulb and means it only has a life of about two hours.

Artificial lighting has the advantage over flash that the effect of the lighting can be seen before the picture is taken, whereas with flash this is not possible.

Artificial light is much more directional than daylight. This means that any shadows will be harder than shadow areas in the open. To obtain a good effect the shadows must be lightened. One way to do this is to place a reflector to throw light into the

◁ Using ordinary colour film in artificial light is not always wrong. It can create fascinating effects.

shadow area. A white sheet hung over something will do this quite well. Study the effect of the sheet and move it till it is in the right position.

An even better way to soften the shadows is to use a second light. This should be of lower power or placed further away from the subject than the main light so that it only reduces the shadows without cancelling out the effect of the main light.

Flash

For shots indoors many photographers use flash which produces a high powered light of very short duration which is suitable for use with 'daylight' colour film.

Nowadays there are a variety of flash units available. These are either built into the camera or fit into the accessory shoe on the top of the camera. Some accessory shoes include the necessary electrical contact to fire a flash gun. On other cameras, or when the flash gun is used away from the camera, a lead is plugged into a socket, usually on the front of the camera.

Magicube
The magicube is a cube with bulbs, each with its own small reflector, set in its four sides. After each flash the unit is rotated so that a new bulb is in position. This enables four flashes to be obtained in succession. The bulbs are ignited by a special striking mechanism. Magicubes can only be used on cameras designed for them – usually very simple types.

Multiple flash units
These are flat units containing eight or ten flash bulbs which are fired in the same way as the magicube. They are usually arranged in two groups. The bulbs in the first group automatically fire in rotation, after which the unit is turned upside down and the second group of bulbs is fired.

Electronic flash guns
Photographers who take many shots indoors use electronic flash units. This type of flash has a tube filled with an inert gas. At each end of the tube is an electrode and when a current is applied to the electrodes a bright flash is produced. This type of unit will give several thousand flashes.

Early flash units of this type

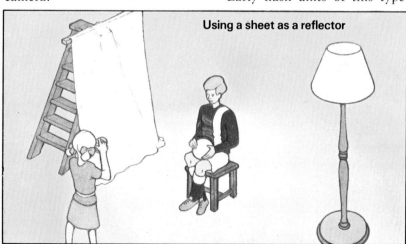
Using a sheet as a reflector

were large and heavy, but advances in electronics mean some are now small enough to be built into a camera. On many cameras with built-in flash units these come into action when the camera's light meter decides that there is not sufficient light for a normal exposure.

Some of the latest electronic flash units have a 'computer' which measures the light falling on the subject and cuts the flash off when sufficient exposure has been given.

Electronic flash guns need a battery to provide the current to activate the electrodes. Remember this battery will need replacing every so often. You have to wait for the flash to charge up before taking another picture. Usually there will be a warning light to indicate when the flash is ready to be used.

Synchronization

The flash of the electronic tube is of very short duration and it is very important that the shutter is open at exactly the same moment as the flash goes off. The flash from an electronic tube lasts from $1/500$ second to $1/5000$ second.

With an electronic flash usually any shutter speed may be used, except on a camera with a focal plane shutter (*see page 27*) when a speed must be selected at which the shutter blinds are fully open.

Read the instruction book for your camera carefully to see what type of flash can be used with it and at what speeds it should be used. If your camera does not have variable shutter speeds just go ahead and use the flash as described in the camera's instruction book. It will almost

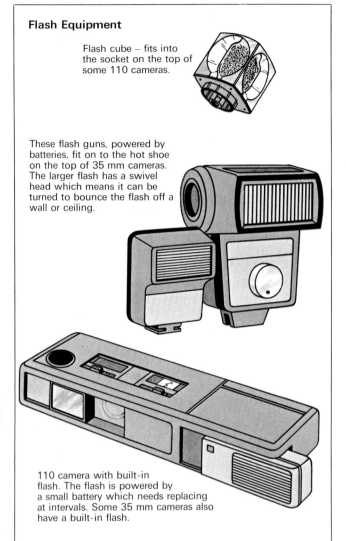

Flash Equipment

Flash cube – fits into the socket on the top of some 110 cameras.

These flash guns, powered by batteries, fit on to the hot shoe on the top of 35 mm cameras. The larger flash has a swivel head which means it can be turned to bounce the flash off a wall or ceiling.

110 camera with built-in flash. The flash is powered by a small battery which needs replacing at intervals. Some 35 mm cameras also have a built-in flash.

undoubtedly be a case of fitting the cube or gun to the flash shoe on the camera, adjusting the camera to the flash setting (if it has such a setting) and going ahead. When you press the shutter button the flash will go off automatically.

Guide numbers

Calculating the exposure with flash is a simpler matter than with other light sources, because the

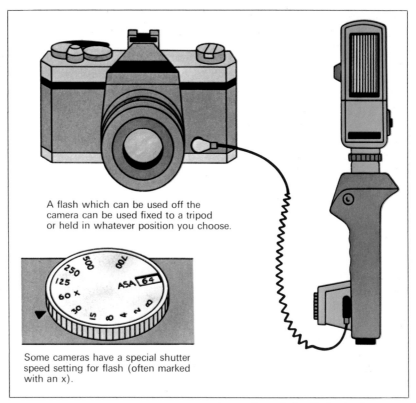

A flash which can be used off the camera can be used fixed to a tripod or held in whatever position you choose.

Some cameras have a special shutter speed setting for flash (often marked with an x).

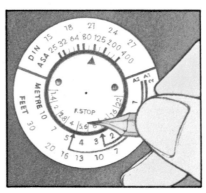

Flash guns for use on a camera with shutter speed and aperture controls sometimes have a dial which shows you which aperture to use. Set the dial to the speed of your film. The dial then shows the aperture you should use for different distances.

intensity of the light is constant. The only variable factor is the distance of the flash from the subject. On a camera with an adjustable shutter and aperture the shutter speed has to be set to secure synchronization with the flash, and exposure can therefore only be controlled by varying the aperture.

The exposure problem has been solved by the flash manufacturers assessing the power of their units in *guide numbers*.

To find the aperture to use it is only necessary to divide the guide number by the distance of the flash from the subject. For instance with a guide number of 17 (metres) – if the subject is 3 metres from the flash, divide 17 by 3 – the result (5.6) is the aperture required. (Care must be taken to check whether the guide number is in feet or metres and to measure

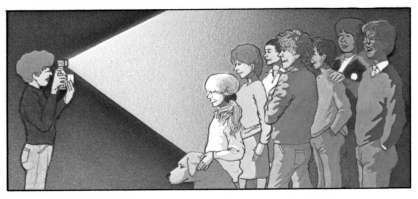

Flash 'fall-off': remember the light from a flash will only cover a limited distance.

the distance in the same units. Also check the speed of film to which it applies.)

The guide number is for a normal sized room with light walls. If using flash in a dark colour room it will be necessary to open up one or two stops to allow for this.

Using flash

One of the difficulties in using flash is that the effect cannot be seen beforehand. In placing the flash unit you have to try to visualize the effect it will produce. The simplest arrangement with the flash unit fitted in the accessory shoe of the camera makes the least satisfactory pictures, because it gives flat, uninteresting lighting. If you use this type of lighting when taking a shot of a person looking towards the camera it may produce an effect known as 'red eye', with the eyes showing red owing to the reflection from the retina. Flash on the camera also makes harsh shadows behind the subject if the background is close to it.

Much better results are obtained if the flash unit can be removed from the camera. Merely moving the flash on to a

Direct Flash

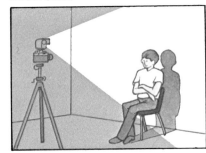

Off-camera Flash

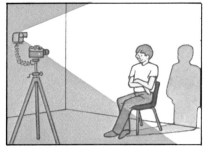

Bounced Flash

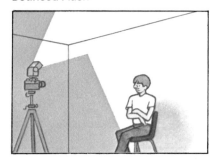

bracket at the side of the camera will make an improvement. An even better effect is obtained by using a flash extension lead of two metres so that the unit can be well away from the camera.

Bounced flash
It is often possible to distinguish shots taken with flash by the fact that the lighting is harsh and the shadows very sharp and dense. For portraits and similar subjects this gives an unpleasant effect.

To obtain softer results photographers with suitable flash units use *bounced flash*. This is exactly what the term suggests; the light from the flash unit is bounced or reflected from some other surface on to the subject. This can be done by pointing the flash gun at the ceiling or wall so that the light is reflected on to the subject. Aim the light at a point midway between yourself and the subject as if you were throwing a ball to the subject by bouncing it off the wall or ceiling. Do not bounce the light off a coloured surface, for that could tinge the light.

The aperture of the lens will have to be adjusted to take into account the longer path of the light from the flash unit to the reflecting surface and from the reflecting surface to the subject. In addition it should be opened up one stop more to allow for the loss of light in the reflecting surface.

Fill-in flash
Against the light shots often produce very attractive results. However, if the subject is a person at a window or doorway there will be a lack of detail in his or her face. *Fill-in flash* is a way of having the best of both worlds. By using flash to lighten the person's face you can have a picture with the 'against the light' appeal but without the heavy shadows.

What is required is to take a picture simultaneously with daylight and flash. The exposure speed must be one that allows the use of flash. If with your camera and flash gun this is 1/30 second, find from an exposure meter or exposure table the aperture needed for a shot at 1/30 second. Say this is $f11$. You now have to find the distance which the flash unit must be from the subject at $f11$. If the guide number is 20, the distance will be 20 divided by 11 – approximately two metres.

Without fill-in flash.

With fill-in flash.

MAKING PICTURES

Good pictures are rarely obtained by chance. Most successful photographs are carefully planned before the shutter release is pressed.

Many people merely take snaps. When they see something which attracts them they lift up their camera, use the viewfinder to make sure that it is pointing in the right direction, and press the shutter release. In most cases the result is disappointing and the photographer says: 'This looked fine, but it doesn't seem to have come out as well as I expected.'

The reason for the failure is that the eye works differently when looking at a real scene than when looking at a photograph. The real scene is large and has depth, so that the eye can wander about looking at details here and there. But the photograph can be taken in at one glance and it is flat with no depth. In taking a photograph you must think of how the finished print will appear. This means choosing the angle carefully and selecting what is to be included in the shot.

This chapter describes many interesting and exciting ways in which the results of your work can be improved.

Big and bold

A picture is always more effective if it shows the subject clearly. Decide what you want to show and keep everything else out of the frame. The main subject should be big and bold.

A common fault is to stand too far from the subject so that it is only a speck in the print. Step closer and have a second look in the viewfinder. You will be surprised how much nearer you can move without cutting off part of the subject. And each move

A mistake to avoid: a delightful shot is spoilt because the subjects are too far from the camera.

Also avoid ugly backgrounds, badly positioned posts and people looking out of the picture!

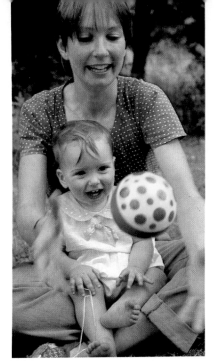

good. By moving to one side you can often get a much less fussy background. In other cases a higher or lower viewpoint will improve matters. If you have a camera with adjustable focusing, you can blur out a fussy back-ground (*see page 19*), using a very large aperture.

Concentrate interest in the picture space by avoiding bright objects near the edge and ensur-ing that the subject (if it is a person or car, for example) faces into the picture, rather than appearing to be going out of it.

Simplicity

The simplest photograph is often the most successful. In a photo-graph, a vast landscape is com-pressed to such a small size that little of its detail can be seen. The view which relies on the interest of a lot of small detail will not make a successful photograph. So choose scenes which have simple, bold lines that will stand out, even on a small scale.

If the top of a range of hills shows as a flat line it will not appear to be very impressive in a print. From another viewpoint, the hills will be seen from the side with a steep slope showing well. A simple pattern of fields, hedges

▷ Concentrate on the main interest and get it big and bold.

will make the subject look better.

When concentrating on the main subject it is easy to overlook other distracting details within the frame. These will be much more noticeable in the print and will draw the viewer's eye away from the main subject. Some of the objects can be moved, others can be put out of sight by a change of viewpoint.

The main subject will stand out better if it is set against a simple background. The sky is ideal, but an even toned hedge or an expanse of grass is just as

▷ Simple compositions with large areas of colour give attractive results such as this shot of a field of oilseed rape, with a church behind it.

and fences can add appeal to a shot of open landscape.

The rule of thirds

Draw a rectangle representing the picture space and in it rule lines showing the thirds horizontally and vertically so that it is divided into nine equal parts.

The four parts where the lines intersect are the strongest points in the picture and are good places to put the most important features. If the main feature of a picture is on the top left third, a secondary feature can be placed on the lower right third to balance it.

A good picture balances about its centre. This does not mean that the two halves must be exactly the same, but that they should have an equal effect. As on a lever, a large object can be balanced by a smaller one further away from the point of balance.

When taking small objects they can be moved around till they are in the right positions, but you cannot move a castle or a tree.

However, by changing your viewpoint so that you see the scene from a different angle the relative sizes and positions of the objects can be changed.

Shapes and lines

A simple way of drawing attention to the main subject of a picture is to have lines running towards it. A road leading up to a house placed on one of the intersections of the thirds leads the eye to it.

A curving S line always makes an effective picture. Watch for curving roads or fences to add power to shots of open country;

See how the bend of the wall catches the eye and leads it through the picture.

A simple, bold composition with the lonely sheep effectively positioned.

The triangle formed by the poles and cloths make a strong setting for the dogs.

The bold lines of the fence and its shadow lead to the church.

The composition is made even stronger by framing the church in the lychgate.

with closer subjects even the swirl of a piece of cloth or the line of a rope will help in this way.

The triangular shape with a broad base tapering to a point makes a good basis for a picture. This is a useful way of arranging three people.

Framing

One of the simplest ways of making a photograph more attractive is by arranging a frame around it. This can be done by taking the shot through an archway or from under a tree, using the trunk and branches as a frame. This is a very good way of adding a little extra to a shot of a scene which is attractive but not quite strong enough to stand on its own. A frame of overhanging branches is also a useful method of filling up the sky area of a picture on a cloudless day.

In most cases the frame should be as sharp as the rest of the picture. If you have a focus control use it carefully so that both the foreground and the distance are sharp. A small stop will help to give greater depth of field. In colour work, however,

where a shot is being taken through a frame of leaves and flowers, a striking effect can be obtained by letting them be out of focus so that they appear as a haze of colour.

Depth

A print or slide shows the scene in front of the camera as a flat surface with no depth. We rely upon perspective to show the depth of the original scene. A man is shown smaller at 100 metres than at five metres; at 300 metres he is smaller still.

In a photograph a line of arches growing smaller, an avenue of trees or even a row of houses all help to show depth. An effective way to view such scenes is from a central point so that the converging lines form a triangular composition, which is one of the basic formations.

Where there is no such indication of depth the effect of distance can be created by having an object in the foreground which gives a clue to the scale of the scene. This can be a person, a car or some other object of recognizable size.

Look up and look down

For most shots 'keep the camera level' is a good rule for it helps to avoid those prints in which buildings appear to be toppling over, or ships look as if they are sailing uphill. But there are occasions when tipping the camera produces striking results. When we look up at a tall building we tip our head backwards and look up. The building tapers away with the same per-

In this shot of an old narrow street the feeling of depth is helped by the diminishing size of the people.

Looking down produces an unusual picture of steps and narrow streets.

The line of arches receding into the distance gives a striking impression of depth.

spective as a distant scene. Capture this with the camera and you have a real eye-stopping picture. For this effect to be successful you must stand near the base of the building and look upwards steep-

model figures. It is a dramatic way of looking at the street which will arouse much more interest than a shot taken in the usual way. Be very careful when working on high buildings.

Low angle

Most photographs are taken at 'eye level' – although what 'eye level' is varies according to the height of the photographer.

Try taking your shot from a very low angle and you will have an unusual picture. Crouch low by a woodland path and get a shot of the path stretching ahead with grass and flowers towering over it and the trunks of trees disappearing upwards. For this kind of shot you need an uncluttered foreground.

▷ Stand close to the base of a tall building and point your camera upwards.

ly, so that you get a really dramatic perspective.

Looking down can produce equally striking pictures. Look over the parapet of a tall building and you will see the street below as a tiny thread with toy cars and

▷ Crouch low and the poppies in the corn provide a beautiful setting for this farmhouse.

High viewpoint

Always take your camera when you are going up a hill or a tall building. From the top you will see the countryside or town laid out before you and this will make a fine picture. Resist the temptation to press the shutter release and make a hasty record, for in a small print the result may look an unintelligible tangle. Look round and find an angle which includes one or two prominent and easily recognizable features which will enable the viewer to identify the area and pick out other details.

Clear conditions are best for this type of shot, and if it is taken when the sun is getting low, so that it gives strong side lighting, the detail will stand out with dramatic clearness.

Upright or horizontal

Most cameras are designed so that they are easier to use in a horizontal position and therefore most pictures are taken horizontally. But the shape of a picture should be governed by the needs of the subject rather than the design of the camera.

Practise holding your camera vertically and find which is most convenient for your hands – to

◁ Tall buildings give dramatic views over cities – especially at night when lighted windows add sparkle.

▽ From high up you can get a bird's eye view of an old town which shows its character.

◁ Most cameras are more easily held taking horizontal pictures – but remember some subjects fit better into a vertical frame.

▷ The strata of slate in a quarry often makes patterns.

have the shutter release at the top or at the bottom. When the shutter release is at the top most photographers find it convenient to operate it with the right forefinger as usual, but when it is at the bottom you may find it is better operated with the thumb.

The vertical position is usually

▷ An unusual shot of a stack of timber.

▷ Farming equipment stacked in a merchant's yard makes a striking pattern.

better suited for trees and tall buildings. It is less useful for landscapes, but can sometimes be used for a view along a road or a narrow stream, or for a scene framed by two tall trees. The vertical shape is also usually more convenient for a shot along a narrow street, or even a wide one if the buildings are tall. Make a habit of checking how a shot would look in the vertical shape. You will be surprised to find that often it makes a better picture than the more usual format.

Patterns

The camera lens is very efficient at recording pattern effects and these can be the basis of many successful and unusual pictures which fascinate the viewer because a picture has been made out of subjects most people would miss completely. For example, in the countryside most farming operations are done to a pattern. From ploughing to harvesting the tractors and implements mark out lines in the fields. These are best seen in fields that slope uphill away from the camera, for then the scene is tipped up in front of the lens. Keep your eyes open: you can find patterns everywhere.

Against the light effects

Photography is making pictures with light. For many years shooting into the light has been a favourite method with photographers using black and white material because it can turn ordinary subjects into exciting pictures.

Against the light effects are not so popular with those using colour film because this is less able to cope with the high contrast and the shadow areas are very dark. However, it is often possible to obtain very good results by choosing subjects where there is no great area of very heavy shadow.

There are two important factors to remember when taking shots of this type. Firstly, exposure must be increased over that indicated by the meter or the

A brilliant against the light shot. The photographer sheltered the lens from the sun in the shadow of the bridge.

Careful positioning of the girl places her in shadow against the light while allowing the sun to light the balloon.

Lens hood

automatic system of the camera, to ensure sufficient detail in the shadow area; and secondly, the camera lens must be shaded from direct sun.

Usually the exposure needs to be increased by one or two stops. If you have an automatic camera it may have a dial which will give this extra exposure; if not it can be 'tricked' into giving extra exposure by reducing the speed of the film setting (*see page 36*).

To protect the lens, a lens hood can be fitted. However, many modern lens hoods are very short and do not provide much protection for the lens. In really brilliant against the light conditions the lens needs more shade and the most effective method is to stand in the shadow of an archway or a tree. If there is no suitable shade available, get a friend to hold a book or map so that it casts a shadow over the lens. Take care that the 'shield' does not appear in the picture.

▷ Black and white film emphasizes lighting effects. This against the light shot makes a striking picture out of a simple subject.

Black and white or colour?

Black and white photography is often looked upon as the poor relation of colour. In fact both kinds of photography have their attractions. Artists have continued to produce black and white drawings although they have always had colour available. They are two different forms of picture making.

▷ The striking pattern of the sculpture set against the twin spires is dramatically brought out in black and white.

Black and white photography is concerned with light and shade and form. It is at its best recording strong lighting effects or simple pattern effects, where colour would be a distraction. It may take you a little time to get used to looking for pictures in black and white because you have to learn to overlook any colour in the scene.

A colour shot will give a better straight representation of a scene, but it can be more difficult to take a striking picture. A red tractor in a distant field will hardly be noticed in a black and white shot, but it may stand out and be a distraction in a colour shot. Try to find simple shots with few colours arranged in broad masses.

Don't try going out with two cameras, one loaded with black and white film and one with colour and hope to get the best of both types. It is better to concentrate on one or the other for any one outing.

One important fact to remember is that if you want to develop and print your own photographs, black and white film is much easier to cope with than colour. And doing your own processing does mean you have much greater control over the final result.

This shot of stark, modern buildings acquires added interest by being shot through window-blinds.

Another simple but striking pattern formed by a line of railings and its shadow – leading the eye to the little dog.

WHAT SHALL I TAKE?

One of the most common complaints by photographers is that they don't know what to take. Their camera stays in its case for weeks. They feel they are not making progress and they lose interest in the hobby.

Photography is the art of seeing. Film is the cheapest item of a photographer's budget. Set yourself a target of a certain number of pictures every week and you will have to keep looking around. In a very short while you will begin to develop a photographer's eye and find that, visually, your surroundings are much more interesting than you thought they were.

This chapter shows you some ways of looking at 'everyday' subjects and also points out some unusual subjects. Try these ideas out and then develop your own

way of tackling different subjects.

As you experiment you will discover the secrets of finding and making exciting pictures.

People

People are among the most popular subjects for the camera. They are also the most difficult, for no other subject has so many changing expressions – and no other subject will criticize the result!

Individual portraits
Avoid the carefully posed studio-type shot. To be successful with this type of picture you have to know how to pose people and how to arrange the lighting. Professional photographers serve an apprenticeship.

Concentrate on unposed, candid shots. Treat the job of taking a picture of a person as you would that of shooting any other subject. Find the angle from which the person looks best, make sure the lighting is right, and press the shutter release.

People often look at their best in pictures when they are doing something because then they are concentrating on their task and are less likely to be embarrassed and to put on a special expression for the camera. Never make anyone pose for too long – they will look bored and unnatural.

If you have a camera with adjustable focusing check the focusing carefully and, if possible, use an aperture of *f*8 to allow

◁ A craftsman at work makes an interesting picture. Here the violin maker is gently rapping the wood and listening to the vibrations.

a reasonable depth of field. (A simple non-adjustable camera will probably have an aperture of about *f*8 or less anyway.) Usually the best lighting for portraits is a little to one side so that while the face is well lit there is sufficient shadow to give shape to the face. Light shining directly on to a face is rarely flattering – and in sunlight the subject will end up squinting.

For a 'head and shoulders' shot stand about 1·5 metres away from the subject. Make sure the background doesn't distract from the person. Indoors, sit your subject about a metre from a window so the light illuminates their face.

If your picture of a person shows them as part of a scene – for example walking in the countryside or playing on the beach – make sure they are not too small. When people are the main subject of a picture you shouldn't really be more than three metres from them.

An important point to watch in taking pictures of people is that your results should always be pleasing. Take a variety of shots

◁ Fill the frame! See how successful this picture is because it follows the rule.

◁ A posed but informal portrait. The dark background concentrates all attention on the girl.

◁ Self-portait many times! Reflections at a fairground make an intriguing picture.

but destroy the shots in which people do not look at their best. If you get a reputation for taking pleasant portraits you will have plenty of people eager to sit before your camera.

Self-portraits

If you cannot find a model, try taking shots of yourself. Most photographers rarely have their own picture taken, so your experiments will produce a welcome result. The experience will also help you to understand how a person feels when he or she is asked to sit before the camera.

The easiest way to take a self-portrait is with a delayed action device, which operates the shutter release about eight seconds after the release is pressed. If your camera has not got a delayed action device you could use a remote shutter release. This has a pneumatic action operated by a rubber ball and a six metre connecting tube. When taking a

self-portrait you have to judge how the position you take will appear in the viewfinder, so it is a good idea to sit at a desk or in some other fixed position.

Self-portraits can also be taken in a mirror or other reflecting surface. (Focus at double the distance from yourself to the mirror.) A curved reflector produces strange distortions. The side of a kettle, one of those convex mirrors sometimes hung on walls, a curved sheet of plated metal – all of these produce a reflection with a difference, which will amuse viewers. And as the photographer is the subject there will be no criticism if the result is a trifle unkind!

Groups

When you are taking a picture of more than one person you have got to make sure that the members of the group look as if they belong together. A picture of three people with each of them gazing in a different direction will look very strange. Take a group of children playing together – the group will look united. Ask people to look at each other or put their arms around each other's shoulders so that everyone seems involved in the group.

For more formal group pictures with lots of people you will have to organize them so that everyone can be seen. Put the tallest at the back, have some people sitting on chairs and some on the floor. Make sure they all look at the camera.

Crowds

Often at an event the crowd blocks your – and your camera's – view of the procession. Press photographers overcome this by holding the camera at arm's

length overhead and pointing it at the action. It is usually easier to hold it upside down. Use a fast shutter speed if you have one to avoid camera shake. A twin lens reflex camera is especially useful in these circumstances as you can still see the focusing screen.

Look for individual faces in a crowd – or a small group of friends enjoying themselves together. Often the expressions on faces in a crowd are more rewarding to record than what the crowd are all staring at!

△ A delightful shot of a wedding in Thailand with all the people engrossed in the proceedings.

◁ It isn't always necessary to show the faces of a group. These walkers will treasure this record of their outing.

▽ A charming picture of a kitten and its owner.

Animals

Animals are difficult subjects because they won't keep still and a great many animals are too timid to let you near them. However they are also very interesting and rewarding subjects so it is worth persevering.

Pets
Pets are probably the easiest animals to photograph. Their owner knows their habits and can usually keep them amused with a favourite game or food while you

If your cat has a favourite perch this will be a good place to get a shot of him.

The boy is obviously proud of his pony and would be pleased with this shot, but try to avoid distracting background details – like the house.

tiny mouse in the middle! Or try taking a picture of a small creature in or on its cage.

Horses

Ask the owner to pose the animal so that its best points are seen. The best view is usually with the animal at an angle to the camera so that all four legs show. When the pose is correct a noise or a cap thrown in the air will make it look alert.

Wildlife photography

Trying to photograph wild animals can be very frustrating as it is very difficult to get close enough for a really detailed shot. Ideally you need a telephoto or zoom lens (*see page 116*) which acts like a telescope and makes faraway objects seem much larger and closer. However, with effort and patience you can get interesting results with some of the simplest cameras.

Remember some wild animals are dangerous – especially if you startle them. Others are terrified of you – don't scare a bird away from her eggs by being too keen to get a picture.

The most important thing to do is to hide yourself and wait very quietly for the animal to appear. Careful research beforehand means you know a good place to wait. Wear clothes which blend into the background and, if necessary, build a rough hide of branches. Try and find a position where the wind is blowing towards you – this means your scent will not be carried towards the animal. Make sure the position will give suitable lighting on the animal – a shot against the light will show no detail.

Have your camera controls set and as soon as the animal appears

snap away. It is often a good idea to include the pet's owner. Aim for a shot expressing the affection between a dog and master or a contented cat curled up in someone's lap.

Think of a way of attracting the animal's attention when you are ready to shoot – call its name or click your fingers.

If you are taking an animal on the ground, get down to its level otherwise it will be small and possibly distorted.

Shots of very small pets, like mice or hamsters, really need a close-up lens for the animals to appear a reasonable size in the finished print. But if you can't get really close with your camera try taking them sitting on their owner's hand and include the owner's face so that you don't have an empty picture with one

◁ In some areas squirrels are so tame that they will let you get close enough for a good shot.

take as many photographs as you can. Some will probably be spoilt by the animal moving.

Bird tables are good places to get photographs, especially if they are near a window. Open the window and you can then poke your camera out through the curtains and take pictures without startling the birds. It is best to choose a still day, as a breeze will rustle the curtains and alarm the birds.

The animals in the local park may be quite tame and easier to approach than genuinely wild animals. If you are lucky enough to have a garden, putting out food in cold weather should attract some interesting subjects.

Zoos and wildlife parks

Zoos and wildlife parks are full of interesting subjects, but always be very careful when dealing with potentially dangerous animals. Don't poke your camera through cage bars or get out of the car or open the car windows in a safari park where wild animals are roaming free.

◁ When animals are in cages, wire netting often spoils the picture. Choose a large aperture if your camera has one and the wire will be out of focus.

In a zoo you can avoid having bars or wire mesh across your photograph by choosing a large aperture and holding the camera as close as possible to the netting. This means the bars or wire near the camera will be out of focus. Never take risks by putting your hands where an animal can bite or peck them! Remember if you use a large aperture in bright light you will need a fast shutter speed. If your camera does not have an adjustable aperture, concentrate on taking pictures of animals outside their cages. There are usually elephants and camels giving rides, and some animals like sea lions and penguins are often in pits or across moats rather than behind bars. The

◁ In a safari park you should be able to get close enough for some worthwhile shots.

faces of the human animals visiting the zoo are worth recording too!

Holidays

Everyone takes a camera on holiday. For the keen photographer it is a time to try out ideas for which there has never been time on ordinary outings. But remember – don't let your hobby spoil the holiday for others. Often the best lighting is early in the morning and if you slip out before breakfast you will be able to enjoy a quiet spell of picture making. At other times of the day, fit in your efforts when the others are reading or resting.

Take some 'holiday snaps' to please the family. Treat these as candid shots and try to show the holiday activities. If you go camping or stay in a caravan, the new form of living will bring many chances for pictures.

Stick to your usual camera and film so that you know how to handle them. Many people get a new camera to take away in the hope that they will get super results, but find that they spoil many shots by making mistakes.

Villages, towns and cities

You will want to make a record of places visited on holidays and on outings. Don't be satisfied with general views of the kind used on postcards. Take one or two of these to remind you of the overall look of a place but then try to get shots which bring out its special characteristics.

Different villages and towns can soon become a jumble in your memory. Try to take a selection of shots which help to create a real picture of the places. Start with a shot of the main street and then pick out the special features that catch your eye – the beautiful old house; the shop with a strange sign; children in the alley.

Searching out these special shots will make you look at the

place more closely and see more than the average visitor does. Make your photographs tell people what makes the village or town different from others.

In old towns the narrow streets make good pictures when the sun is shining along them. Shooting against the light (*see page 78*) shows the uneven rooftops and the gables. Look for details of carvings, big brass doorknockers or flowers against white-washed walls.

Many towns and villages have markets. Find out which is market day and go along with your camera. Cattle markets are full of interesting pictures of animals and people. Fruit and vegetable stalls are very colourful and the produce is often laid out in interesting patterns. People get excited at markets – watch their faces and keep your camera ready.

Large cities with their huge buildings and busy streets may seem much to big to cram into the small 110 or 35 mm negative. Take up the challenge. Modern buildings, with their pattern of windows, make frame filling shots. Tip the camera upwards and the lines soar away in striking perspective. Look down from the top of one of these buildings and the street is a narrow slit with little people and toy cars. Multi-storey car parks look like shelves in a cupboard. Statues, street vendors, shop signs can be interesting too.

Waves always make good photographs – watch for the big one.

The seaside

It is easier to make pictures at the coast than in the countryside, because the scene is simpler. Often there are only the lines of the sea, the sand and the cliffs to consider. Put the horizon above or below the centre of the photograph so that it does not divide the picture into two and include a large rock, a boat or a figure in the foreground to give interest to the print.

The sea itself makes many pictures. On calm days the foaming water spreading out on the sand makes intriguing patterns, and on stormy days dramatic pictures of waves breaking over the rocks can be captured – wait for the 'big one' that throws foam high into the air.

Remember that salt water can ruin a camera so keep your hands dry and see that the camera does not get splashed. A UV filter (*see page 104*) will protect the lens and its clear glass will not affect the result.

Look in rocky pools for shots. The clear water and bright colours of rocks and seaweed make good pictures. Choose a pool in the shade so that the sky is not reflected in the water.

It is usually very bright at the seaside because light is reflected from the sea and the sand. Be very careful not to overexpose your pictures. If your camera has a simple control for bright or dull

Simple pictures are always most effective. Here a low viewpoint has made a fascinating shot of the pools left by the tide.

In the harbour look for interesting pictures of the fishermen and their nets.

Look around – an ordinary breakwater can make a striking picture.

days, use the bright setting at the seaside even on a cloudy day. With an adjustable camera choose a small aperture.

Seaside towns usually have other exciting subjects as well as the sea and the sand. Around the harbour the boats and gear of the fishermen are always good targets for the camera.

At those resorts with funfairs take your camera to capture the bright colours and laughing faces. Pictures of moving roundabouts are a challenge. If the motion is towards the camera, shutter speeds do not need to be so high (*see page 97*). At dusk the lights show up better.

The countryside

The countryside is one of the most inviting subjects and also one of the most difficult. You will often reach for your camera to take a vast view – and then find that it looks uninteresting in the print. You can't expect to get the feeling of vastness so when you look through the viewfinder remember how small the features will appear in the print.

To be a success the picture must have a few bold masses and simple lines – perhaps a sloping hill across the foreground with a bold hill in the distance. Hills look more impressive if you take them from an angle from which they have a craggy outline. A person or tree in the foreground will give scale to a distant landscape.

In a small print little of the detail can be seen. Pick out one feature and let it dominate the picture. Use the lines of roads and hedges to lead to the main feature of the picture.

A beautiful shot with a farm providing interest in the foreground.

Many country activities make good pictures. Thatchers, hedge trimmers and other craft workers show skills that are gradually being lost as machines take over. Your picture of a craftsman at work will provide a record of skills that are being lost.

Flowers and trees are good subjects. Close-ups of flowers are dealt with later (*see page 117*) as special close-up lenses are needed, but with ordinary equipment shots of flowers in drifts can be taken.

Use your camera to make portraits of trees. Old trees that have stood for years against the wind are grand subjects. Tip the camera up to set the branches against the sky as the new leaves are coming.

Get down low to fill the frame with flowers.

The changes brought about by the seasons are particularly noticeable in the countryside. Try to take the same scene at different times of the year and in different weather conditions. Grouped together, the results will provide a striking record of a favourite scene.

▷ The same tree shot at different times of the year makes a very interesting series of pictures as well as a lovely record of the changing season.

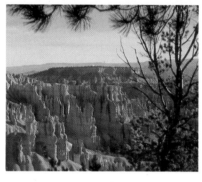

▷ Careful choice of position brings out the dramatic nature of this scene.

▽ This series of shots over the rooftops of London show how effective a panoramic view can be.

Panoramic views

There are times when you wish that you had a very wide-angle lens so that you could squeeze in all of a view. In fact a wide-angle lens would not solve the problem properly because it takes in a wider view vertically as well as horizontally. The difficulty can be overcome by taking a series of pictures and joining them together. For this type of shot a distant view with an interesting skyline is best.

The camera should be kept on the same level for all the shots. You may be able to do this holding it in your hands, but it is better to have a tripod or some other firm level support. Try resting the camera on a gate or wall. Begin by making the first exposure on the far left (or right) and then take a series of shots till the other side of the view is reached. The edge of each shot should slightly overlap the preceding one. Try to include a prominent feature in the overlapping sections as this will make it easier to see how the prints fit together.

When you receive the prints back, join them together to make one copy of the panoramic view. The joins will be less obvious if cuts are made along the outlines of a hill or a building. If the camera was not held at exactly the same height for all the shots, trim the top and bottom edges.

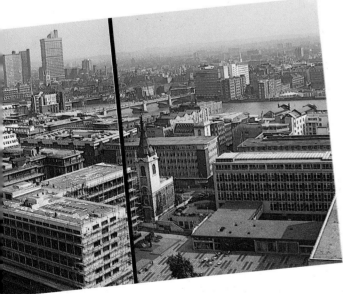

Weather effects

Bright sunshine produces the best photographs of most subjects. It brings colour to colour photographs and detail to black and white shots. But there is no need to put your camera away when weather conditions are not so good. Other types of weather produce effects which are just as striking if you look for them instead of complaining about the lack of sunshine. People will be surprised to see attractive pictures taken in bad conditions.

Your camera must be well protected for outings in the rain. Keep it in a weatherproof case and only take it out when you see a possible picture. Put a UV or skylight filter (*see page 104 onwards*) on the lens. This will not affect the exposure required, but will protect the lens from raindrops. Some photographers work with their cameras in transparent plastic bags with a hole cut out for the lens. This ensures that no water gets inside the camera.

Clouds
Clouds are the landscape photographer's best friend. Good

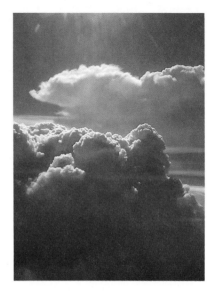

Watch the sky. Dramatic formations of clouds make striking pictures.

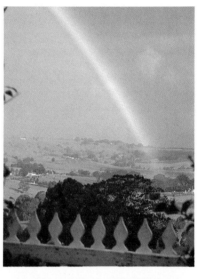

Colour film can catch a rainbow. The effect is best with a dark sky behind.

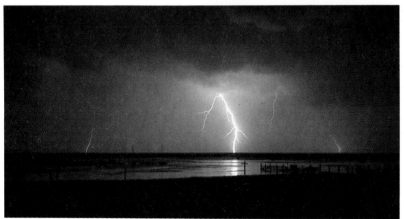

Try to catch a streak of lightning for a really dramatic picture.

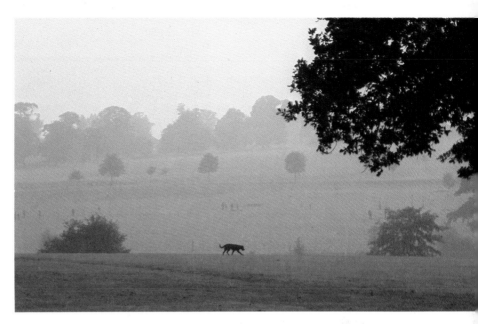

▷ Misty conditions can make good pictures and note how the dog has added interest and depth.

clouds can make even an ordinary scene look attractive – especially in black and white shots, where a plain blue sky comes out white.

Clouds can also make pictures on their own. For these the horizon should be placed as low as possible so that the clouds fill the frame. The cottonwool cumulus clouds make good pictures – especially when they fill the sky – and cirrocumulus clouds, often called a mackerel sky, are also very effective.

Rainbows

Another good sky subject is the rainbow. In colour they are easy to take; in black and white they stand out best when the sky behind is very dark.

Lightning

Ligtning can be recorded by setting up the camera on a tripod or some other firm support with the lens open, pointing in the direction of the storm. Usually it is best to keep the lens open to record two or three flashes. A dark setting with no traffic is best.

Mist and fog

Mist and fog bring an air of mystery. You won't be able to take straight record shots of places, but you can make intriguing pictures. The most effective mist pictures are taken against the light – just as the sun is breaking through, or when car headlamps are glowing through the mist.

Objects which are near the camera show up quite sharply, so look for something to give interest in the foreground. Perhaps some people by a bus stop, a tree or a church with a shapely spire. In the open countryside, mist often hangs low so that tall trees and hills stand out as if they were in a sea.

If the ground is wet, roads, pavements and kerbstones will glisten in the light and make a picture from a scene which would otherwise be uninteresting.

Mist is usually best in black and white shots, but experimenting will show that appeal can be added by the use of colour filters (*see page 104*).

Rain

Rain makes damp surfaces which reflect light and striking results can be obtained by taking shots which are angled towards the light.

It is not possible to take shots of raindrops falling. Even when they are quite large, they rarely show up strongly enough unless there is back lighting and a dark background, and then their movement is so fast that they appear as streaks on the print. To show falling rain drops the best results are obtained by taking them hitting a pavement and bouncing up or by catching the splash rings as they fall on puddles. These shots can be taken from the shelter of a doorway.

Raindrops can also be shown on windows. They need to catch the light, and a dark background is best. Focus on the window so that the raindrops are clear and the scene outside is made up of hazy shapes.

In town the best effects come with heavy rain when the roads and pavements are awash with water so that they reflect the scene well. The brightly lit shop windows make a dazzling picture and brightly coloured raincoats and umbrellas add to make a surprisingly colourful scene.

In the countryside rain puts sparkling droplets on leaves and branches, while the ditches are full of rushing water.

Snow

A fall of snow makes a new world. The untidy detail is covered up. The countryside becomes a clean white sheet patterned with the dark lines of hedges and fences. In town, the ground, roof tops and other horizontal surfaces are white, with walls and

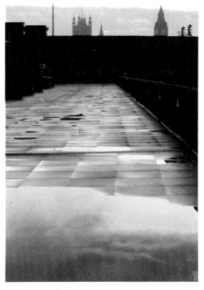

◁ Look out for reflections in puddles.

posts standing out starkly black.

The best conditions are when there has been a heavy fall of snow followed by a cold morning with some bright sunshine to add sparkle to the snow. The dazzling white snow will make the meter (or the automatic exposure system on the camera) indicate an

▽ The anoraks of the walkers add a dash of colour to this impressive snow scene.

indoors so that the first two metres in front of the lens are free of snowflakes.

In the country everything is covered with snow and immediately after a fall the scene is like a wonderland. The untreated roads will have deep ruts worn by vehicles, with shadows showing starkly.

Old towns and villages with low buildings and timber-framed houses make delightful pictures after a snowfall. In large towns snow makes less interesting pictures because modern buildings do not have many projections so that they do not show the effect of the snowfall. Look for the details – snow on statues and icicles hanging from gutters.

△ After a big snowfall, snow fights and other games make bright pictures.

exposure which is too high because snow reflects the light. Give one stop extra exposure to correct this. On a simple camera choose a setting for bright sunlight if you have one.

Falling snow is as difficult as rain to catch in a photograph, but as the snowflakes are larger than raindrops and usually fall more slowly, a shutter speed of 1/125 second or 1/250 second will catch them. Unfortunately the flakes near to the camera will show up as large as snowballs. A good way to overcome this is to shoot from

Sunsets
The vivid colours of sunsets are good in colour or black and white. These shots can often be improved by including foreground subjects in silhouette – trees, a church on the skyline, or an interesting line of hills in the distance.

Don't make your exposure too short if you have a choice of shutter speeds – you want to record some of the detail in the scene. Experiment with different exposures and look closely at the results.

▷ Sunsets change rapidly and the best effects only last a short while – so have your camera ready!

Action

Action shots are always appreciated. Taking this type of shot is a good test of your progress because success depends on the ability to handle your camera confidently.

The most important factor in taking action shots is to be able to press the shutter release at exactly the right moment. Practise with a camera without a film in. With most cameras if you press the shutter release carefully you will find a point at which the smallest extra pressure will trip the shutter. When you want to make the exposure you have only to move your finger a fraction of an inch. Practise taking up the first pressure and completing the action smoothly. In this way you will be able to fire the shutter at exactly the moment needed to catch the action. Always press the shutter release smoothly – there is a temptation to stab at it quickly to catch action, but this only leads to a blurred result caused by camera shake.

There are four main ways of taking action shots:

Moment of stillness

With this method it is possible to take dramatic action pictures with even the simplest camera. In many actions, such as swinging on a swing, bouncing on a trampoline or swinging a golf club, there is a moment when movement changes to the reverse direction. At this moment the subject is stationary. An exposure made to synchronize exactly with this moment of stillness can be quite slow – 1/60 second is accurate; a shot at 1/125 second allows a margin.

Watch the action several times so that you can estimate when the moment of stillness will occur. Then follow it through the viewfinder with your finger poised to press the shutter release. The action will seem to take place in slow motion and it becomes simple to press the shutter release a fraction before the right moment, to allow for your reactions.

Using the shutter

To 'stop' action with shutter speed is more difficult. There are three factors – the speed of the object, the direction in which it is travelling, and its distance from the camera.

You can judge the effect of these when riding in a car. Look straight ahead and you will be able to see objects quite clearly; at 45° through the corner of the windscreen there will be more difficulty in distinguishing things; look out of the side window and the nearest objects will be a blur, but things further away will be easier to see.

You will see from the table that a faster shutter speed is needed for athletes than for cars travell-

◁ At the peak of the swing there is a moment of stillness when quite a slow shutter speed can be used.

Shutter speed guide

Direction of movement	↕	⤢	↔
Cars – up to 32 kph	1/60th	1/125th	1/250th
Cars – up to 48 kph	1/125th	1/250th	1/500th
Cars – up to 96 kph	1/250th	1/500th	1/1000th
Cars – racing	1/500th	1/1000th	1/2000th
Walking slowly	1/30th	1/60th	1/125th
Walking quickly	1/60th	1/125th	1/250th
Athlete running	1/250th	1/500th	1/1000th
Trains at 96 kph	1/250th	1/500th	1/1000th
Horse racing	1/250th	1/500th	1/1000th

These speeds are for objects at 7·5 m. At 3 m halve the speeds (1/250th for 1/125th). At 15 m double the speeds (1/60th for 1/125th).

ing much faster. This is because in the case of the athlete the movement of arms and legs has to be taken into account as well as the forward motion.

For most shots the 45° angle looks most exciting.

Panning

Racing cars passing directly in front of the camera are often travelling at too high a speed for even the fastest shutter speeds to stop the action. Professionals overcome this by 'panning' – that is swinging the camera with the moving object so that it is kept in the same place in the viewfinder and on the film, so that there is no movement of the image.

Stand with feet apart facing in the direction you intend to take the shot, then turn your body towards the direction from which the car is coming. Frame it in the centre of the viewfinder and swing round keeping the car central in the viewfinder. As it reaches the point where you want to take the shot, squeeze the shutter release following the

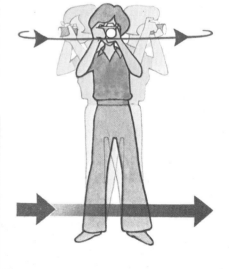

▷ Even the highest shutter speed could not catch this racing car. By panning with the action, a speed of 1/125 could be used. The blurred background helps give an impression of speed.

For action shots such as this, with motion in several directions, a high shutter speed is needed to give a sharp result.

A high shutter speed of 1/500 or 1/1000 was needed to catch the action of the canoeist and the sparkling water.

car as it goes past you. The follow-through is vital, for if you stop swinging as the shutter release is pressed you will lose the motion. With practice racing cars can be taken at a speed even as slow as 1/125 second using this method. In most cases the background will be blurred because of the movement of the camera, but this adds to the impression of speed.

Blur

The way in which the blurred background of a 'panned' shot helps to suggest movement is a hint to the fourth method of taking speed shots – *blurred action*. This is similar to the device used by artists who often indicate action in drawings by putting lines behind figures.

In a blurred action photograph the aim is to allow part of the action to be blurred to create an impression of speed.

If there is too much blur, however, the subjects will not be recognizable. For most subjects 1/30 second is a good speed, but try also a shot at 1/15 second.

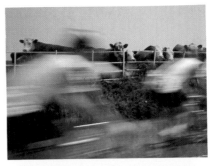

Another way of showing speed is used here when a slow shutter speed produced a blurred picture of racing cyclists.

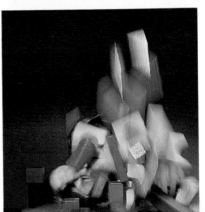

An exposure of 1/15 second has produced an unusual picture of a child's toy bricks falling down.

98

Reflections fascinate people and make interesting photographs. The problem of focusing is one that puzzles many photographers. The simple rule is that the image is as far behind the surface of the mirror as the subject is in front of it. The camera lens must therefore be focused at the distance from the lens to the mirror plus the distance from the mirror to the subject. If you want to have the surroundings of the reflecting surface sharp, a small stop must be used to ensure sufficient depth of field.

The clearest reflections are seen when the subject is brightly illuminated and the mirror is in a shaded position. The reflections in mirrors in the house or on the wings of cars make good subjects. The polished hub caps of a car often reflect a place visited or the family enjoying a picnic. This type of shot requires accurate framing; remember to use the parallax marks if working near to the mirror. Include sufficient of the surroundings to enable anyone looking at the print to

▷ A beautiful cat beautifully reflected on a car bonnet.

▷ Motoring reflections! A clean car will reflect its surroundings on the paintwork, hub-caps and bumpers.

▷ Rivers often provide intriguing reflections. Here a bridge and trees are exactly duplicated in the water.

know that they are looking at a picture of a reflection.

At certain angles there are good reflections in the glass of windows, and you may get striking pictures when the view through the window combines with the reflection.

Some of the best reflections are seen in water. In good conditions the reflections are so perfect that if the waterline is set in the middle of the picture it is almost impossible to tell which is the right way up.

A clever shot catches the reflection of the building opposite the window.

Shadows

Shadows are as fascinating as reflections. You can show a long, thin 'distorted' shadow or a shadow which is an exact replica of the object.

A silhouette, at one time a popular style of portrait, is an exact shadow of a subject. They can be produced by hanging a sheet in a doorway and then arranging a spotlight so that it throws a shadow of the face of the subject on to the sheet. Another way of making silhouettes on black and white film is to set the person about one metre from a plain wall and to arrange a light to illuminate the background brilliantly while not lighting the sitter. An exposure for the well-lit wall will leave the face of the sitter in silhouette.

A popular type of shadow picture is to take one's own shadow when the sun is low in the sky and producing very long shadows. If the ground ahead slopes downhill, even longer shadows will be made.

At times objects throw shadows which have the shape of faces or animals – making this type of

The reflection of two girls is caught in a car wing mirror.

A shadow self-portrait. The steps make the picture more intriguing.

shadow with one's hands used to be a popular game. When taking a shot of this type of shadow include the object casting the shadow.

▽ A very simple sequence of shots will make an amusing picture story. Add a few words to each picture and it will make a lovely present for the little girl.

Picture stories

A sequence of pictures telling a story can be great fun to take and to show to other people. A younger brother or sister might like a record of 'a day in my life'. You can add a few words to each picture and make the photographs into a little book.

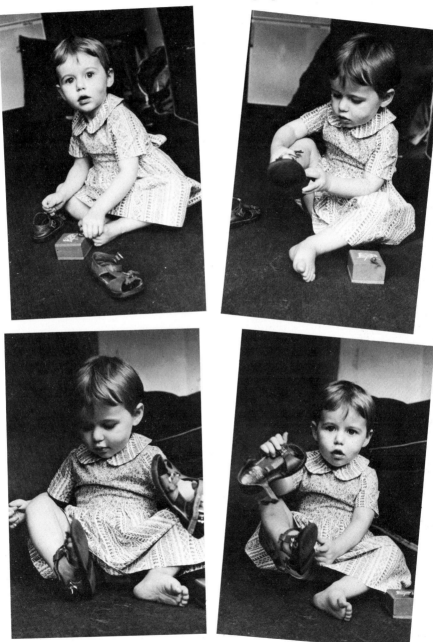

Unusual subjects

A camera is not only for recording things we can actually see. The camera can be used to play tricks as well. Here are some ideas for taking 'trick' subjects and for some other unusual subjects too.

Ghosts

To make a picture of a 'ghost' you need a camera with an adjustable aperture and shutter and an assistant dressed in a sheet. Set the camera up on a tripod and choose an aperture which will need a long exposure, say six or more seconds. After half the exposure close the shutter while the 'ghost' moves away. Wind the shutter with the rewind button pressed so that the film stays still and complete the exposure.

Writing with light

For this you need a camera with a B setting (holding the shutter open for as long as you wish) and an assistant. Set the camera upon a tripod and focus on your assistant. Put out the lights, give the assistant a torch and tell him or her to write (in reverse) with the torch in the dark. Open the shutter on B while he or she is writing.

Accidentally on purpose

People often accidentally take photographs with trees looking as if they are growing out of someone's head or some other unfortunate effect due to the fact that photographs 'flatten' a scene. Objects which look a long way apart to us end up squashed together on a photograph. But you can use this effect to create

◁ A photograpn of a ghost playing the piano should give your friends a shock!

◁ Play around and see if you can get a trick shot like this.

▽ A shot through a car windscreen can be interesting. Make sure the windscreen is clean.

Waterfalls taken at different speeds. The one on the left was taken at 1/1000 second and the one on the right at 1/30 second.

amusing results – someone 'holding up' a building or 'balancing' a friend on their hand.

Car windscreens
On a car journey you often see a good picture through the windscreen. Take a shot at 1/250th second and it will be sharp. Try an exposure at 1/60th second and the distant view will be blurred, giving an impression of speed. Include part of the car in the shot to show it was taken through the car window.

Moonlight
Take a photograph in the twilight when the full moon is just rising.

Fireworks make dramatic pictures but you will need a tripod to hold the camera steady.

Underexposure will add to the moonlight effect. The moon usually comes out very small. A useful dodge is to take the moon separately with a telephoto lens and then combine it with a landscape shot.

Candlelight
Candlelight looks attractive, but calls for a long exposure to take the scene and then the flame of the candle is 'burnt out' in the picture. The problem can be overcome by making an exposure sufficient to register the candle flame and then bouncing a flash off a wall to give a very soft light from the right direction for the general scene.

Water moving
Moving water in rapids or waterfalls looks impressive but it is difficult to get a shot which shows the excitement of the scene. If too high a speed is used, the water is 'frozen'. If the shutter speed is too slow, the water will be a blur. The best speed is 1/125 second.

Fireworks
Put the camera on a tripod and open the lens on the 'B' setting, keeping it open to record several fireworks in the sky. This will give a more exciting picture.

A *CCESSORIES*

The accessories described here are not magic attachments which will suddenly bring a great improvement in results, but are devices which will help with particular difficulties. A sound basic rule is to keep photography simple. Before buying a certain accessory think how many times you could have used it in the previous three months, then you will know whether it will be worth its price.

Not all cameras will take the accessories described here. Check with your instruction booklet.

Filters for black and white photography			
Filter	**Effect**	**Filter factor**	**Increase exposure by**
Yellow	Lightens yellow, darkens blue. Main use is to darken the blue of the sky and so bring out white clouds.	2X	1 stop
Yellow/green	Similar in effect to the yellow filter, but also lightens green a little so giving more varied tones in heavy banks of trees.	2·5X	$1\frac{1}{4}$ stops
Green	Lightens green tones and darkens reds. Rather specialized in use. Mainly used to brighten the colour of dark green lens and to 'improve' suntan in portraits.	4X	2 stops
Orange	Darkens blue and green and lightens orange and red. Produces dramatic looking effects when sky is deep blue. Often used for architectural shots.	2·5X	$1\frac{1}{4}$ stops
Red	Darkens blue and green and lightens red and yellow. Produces dramatic rendering of blue skies.	8X	3 stops
UV	No effect on rendering of colours. Reduces haze in distant shots. Useful to keep on the lens all the time to protect it from rain and fingermarks.	1X	No increase

Filters

A filter is a disc of coloured glass or gelatin which is screwed or clipped on the front of a lens to alter the look of the resulting print or transparency. Filters have different roles in black and white and colour photography.

Black and white film is more sensitive to some colours than others. By placing a coloured filter in front of the lens that colour is lightened in the print and the *complementary* colour darkened. Sunlight, or light from an electric light bulb, is called white light. White light is actually a mixture of many different colours. Any two colours that produce white light when they are mixed are said to be complementary colours. Yellow light (a mixture of red and green light) is the complementary colour to blue light. Together they give white light. In the same way

▷ Without clouds in the sky many scenes look 'bald' and uninteresting. The sky is just one overall shade.

▷ A yellow filter will make the blue sky appear darker so that the clouds show up better.

magenta is the complementary colour to green and cyan is complementary to red (*see page 156 also*).

With colour film all colours are recorded, so adding a coloured filter increases the amount of that colour in the print. Filters are also used in colour photography to alter the colour of light to bring it up to 'normal' standard. For instance on a rainy day the light is very blue, so a pale amber filter can be used to warm the tones of the print or transparency. A filter may also be used with daylight colour film when taking a shot in tungsten (ordinary electric) lighting.

The difference in the effect of filters in black and white and colour photography must be remembered. An orange filter makes the blue sky dark and shows up the white clouds in a black and white photograph; in colour the same filter gives an overall orange colour to the result.

It is important to remember that a filter absorbs some of the light and therefore extra ex-

Using a red filter with black and white film brings up a dramatic sky but also darkens the greens of the trees.

posure may be needed. This is known as the *filter factor* and indicates the extra exposure needed: for example, 2X equals two times or one stop.

If you have a camera with TTL metering (*see page 45*) you would expect it to take account of a filter placed over the lens. But in some cases it will not do so because the sensitivity of the meter to colour

A red filter with colour film just gives an overall red tinge.

is not the same as that of the film. Experiment to see what adjustment is needed. If you buy a filter check its filter factor in the accompanying instructions.

Filters will not produce clouds out of a clear sky on black and white film. Remember their effect is to darken the blue and thus make white clouds show up better. In black and white work do not give too much exposure with a filter. The effect of the filter is greater with slight underexposure.

Filters for colour photography

The effect of a filter in colour photography is different from

Screwing a filter on the lens

Filters for colour photography			
Filter	**Effect**	**Filter factor**	**Increase exposure by**
Skylight 1A	Corrects the bluish tinge in shots taken when the sky is dazzling blue. It also helps to reduce the bluish cast of portraits taken in the shade on such days.	1X	No increase
Skylight 1B	Slightly deeper in tone than the 1A filter and thus provides greater correction.	1X	No increase
Cloudy 81A and 81B	Warms up the tones of colours in shots taken on cloudy or rainy days. In general landscapes you may prefer to preserve the natural lighting of the scene.	1·5X	$\frac{1}{3}$ stop
82A	A pale blue filter to cool the yellowish tones of shots taken in the early morning or in the evenings. As with the 81A and 81B you may prefer the natural rendering.	1·3X	$\frac{1}{3}$ stop
80B	A blue filter to cool the orange-red tones of shots taken in tungsten lighting on daylight colour film.	4X	2 stops

that in black and white photography. As the film records colour, the effect of the filter is to tint the colour of the image and it does not change the contrast.

Cheap filters

To obtain the best results photographic filters are made of optical glass specially selected and produced to a high standard. However, for small prints or to experiment with the effects which various filters produce, pieces of coloured cellophane can be used. (Some photographic dealers supply squares of coloured gelatin specially for this puporse.)

Try the effect of various cellophane 'filters'. One experiment you can try is to cut a circular hole in the centre of the cellophane so that the main subject is surrounded by an area which is toned in a different colour.

Polarizing filters

Unlike the filters discussed above, the effect of a polarizing filter is the same in black and white as in colour. It is made of light grey or brown material similar to that used in some sunglasses and has the property of cutting out unwanted reflections, such as those in windows, which consist of polarized light.

The effect can be seen if a shiny surface is viewed through a piece of the material. By rotating the material a position will be found at which the reflected light is cut off. The effect does not occur with light reflected directly back or with reflections from metal surfaces.

For the photographer this filter is most useful for cutting out reflections on glass to enable the contents of a showcase to be photographed; for cutting out

Filters

Without a polarizing filter, there is a reflection in the table.

Using a polarizing filter removes the unwanted reflection and concentrates all interest on the subject.

reflections on the surface of water so that items in the water can be seen; for taking the shine off smooth surfaces such as tables or book-covers so that the detail can be seen and for deepening the blue of the sky by eliminating the

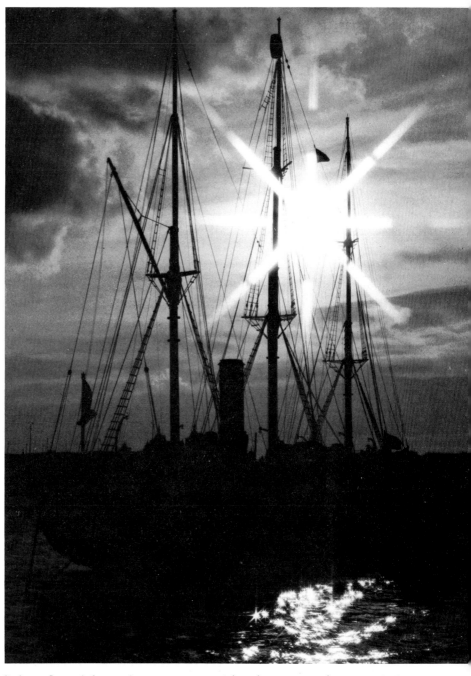

A star burst attachment produces starlike bursts around bright lights.

light reflected from the water in the air.

These filters usually have a factor of 4.

It is easier to use these filters on SLR cameras because the effect can be seen in the viewfinder, but with other types of camera it is only necessary to turn the filter till it cuts out the reflection and then to place it on the lens in that position. Material from Polaroid sunglasses can be used for taking shots to see the effect.

Special effects

There are a number of lens attachments which produce special effects. Most of these have only a very limited use so they are best thought of as producing amusing variations rather than being accessories for serious photography.

Star bursts
These produce starlike bursts round naked lights and other very bright spots in a picture. There are various types which produce four, six and eight pointed stars. The effect shows up best when there is a dark background. The four-pointed stars are usually the most striking.

Centre spot
A useful device for shooting portraits, this has a clear centre spot surrounded by an area which gives a soft focus effect. This makes the portrait stand out boldly from the rest of the picture. The effect can also be obtained by putting a layer of grease round the outer edge of a plain filter such as a UV filter.

Multi-vision lens
These attachments have several faces and produce three, five or six images of the subject on one film. They are best used for taking a single subject against a plain background so that all the images show up clearly. This is another attachment which is best used with an SLR camera so that the effect can be studied before the shutter release is pressed.

Split field
This attachment combines the equivalent of a close-up lens with an area of plain glass, so that it is possible to take a very near subject and a more distant one at the same time – for instance a close-up of a football trophy with a shot of the team in the distance. In order to position the objects precisely it is really necessary to have the reflex viewfinder of an SLR camera.

A centre spot gives a soft focus effect around the edges.

An example of the five image multi-vision lens.

ALTERNATIVE LENSES

One of the most important advantages of the SLR camera is that it is usually possible to fit lenses of differing focal lengths. This extends the range of subjects you can take.

There is a snag – you have to pay for the extra lenses. If you buy several they will probably cost more than the camera itself.

Some 110 and 35 mm compact cameras have semi-wide angle lenses of 33 mm which can be converted to telephoto lenses of approximately 70 mm by means of a switch. But this is a very limited change.

Photographers often talk of the *perspective* effect obtained by

A scene taken using a 50 mm lens.

Using a 135 mm lens. Note how different the weir in the background appears in each picture.

using different lenses, but from the same viewpoint all lenses give the same perspective. A lens of shorter than normal focal length has a *narrower* angle of view and therefore objects appear larger than normal. However, if the negative from the shorter focal length lens is enlarged till the central area is the same size as that from the long focal length lens it will be seen that the perspective is the same.

Lenses of differing focal lengths do, however, encourage you to produce pictures with differing perspective. With the short focal length lens you have to get nearer the subject for an image of the same size and this gives steeper perspective; while with a long focal length lens you have to stand back further and this makes a 'flatter' perspective.

Remember these points and you can produce many special effects by changing the lens.

Short focal length lenses

A lens of shorter than normal focal length has the advantage that it includes a wider angle of view which for many landscape subjects gives a more natural appearance than the normal lens. And it is often useful when taking shots indoors when there is not room to get far enough back to get everything in with a standard lens. These lenses also have a greater depth of field than the standard lens.

The 50 mm lens is the lens normally used on 35 mm cameras.

The 135 mm lens reaches right down the river.

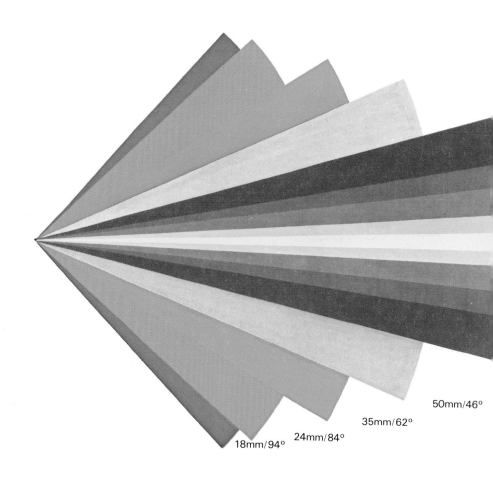

50mm/46°

35mm/62°

24mm/84°

18mm/94°

The 400 mm lens shows the detail on the distant weir.

The 28 mm lens takes a wide view of the riverside scene.

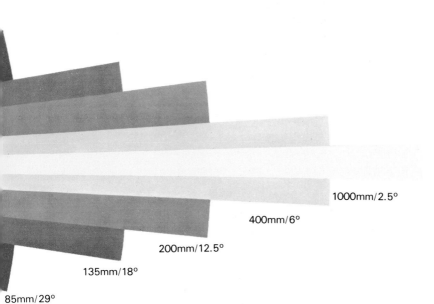

1000mm/2.5°

400mm/6°

200mm/12.5°

135mm/18°

85mm/29°

Angles of view

This diagram shows the different angles of view lenses of differing focal lengths would give from the same viewpoint. A standard lens has a focal length of 50 mm.

The most usual short focal length lenses for 35 mm cameras are 35 mm, 28 mm, 24 mm and 'fish-eye'.

35 mm lens
This is a very useful lens which many photographers use as standard for taking landscape shots as it takes in a wide view without the dramatic changes produced by the shorter lenses.

28 mm lens
A lens of this focal length takes in a wide expanse of landscape. However, it also has a wider angle of view vertically so there is a wide expanse of foreground. It is therefore best used when there is an interesting foreground.

20 and 24 mm lenses
Lenses with these very short focal lengths produce dramatic effects but they will cause distortion in a portrait shot of someone near to the camera. They emphasize the foreground and make a compelling picture of subjects where this is important, such as an expanse of wet tide-rippled sand.

Fish-eye lens
This is a 'fun' lens producing circular pictures covering an angle of 160°-180°, with curved lines on the edge of the picture. When you first use a fish-eye lens the fantasy of the results is fascinating, but when the novelty wears off you may only rarely find a use for it.

Long focus lenses

Long focus lenses produce a larger than normal image of the subject. Nowadays most of these are *telephoto* lenses. This term

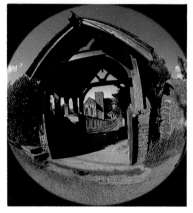

With a fish-eye lens the lychgate of the church bows outwards, showing the peculiar 'barrel' distortion of this type of lens.

indicates that the distance between the lens and the film is shorter than the actual focal length.

The long focus lens covers only the central area of the view of a lens of normal focal length. The absence of the foreground makes the perspective appear to be compressed – a familiar effect is the way that shots of racing cars at corners look very exciting because the cars appear to be closer together than they actually were.

Long focus lenses have a shallow depth of field which is useful when you want to separate a subject from its background.

A danger with these lenses is camera shake. As a guide some photographers judge the lowest speed at which a lens may be safely hand held by its focal length: 100 mm – 1/100 second; 200 mm – 1/200 second, etc.

Long focus lenses can be divided into three groups: 85 and 100 mm; 135 and 150 mm; and 200 mm and over.

85 and 100 mm lenses
These are the most useful long focus lenses for general purposes. They are very convenient for taking unposed portraits because they give a large image without

Lenses

Zoom lens

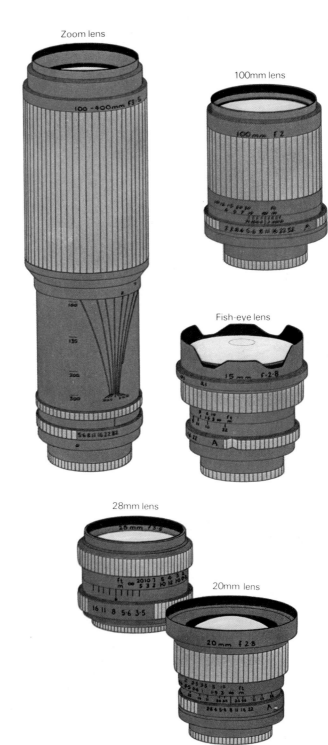

Zoom lens

100mm lens

Fish-eye lens

135mm lens

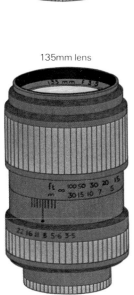

28mm lens

20mm lens

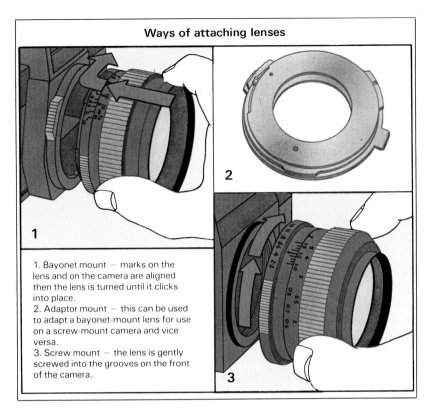

Ways of attaching lenses

1. Bayonet mount – marks on the lens and on the camera are aligned then the lens is turned until it clicks into place.
2. Adaptor mount – this can be used to adapt a bayonet-mount lens for use on a screw-mount camera and vice versa.
3. Screw mount – the lens is gently screwed into the grooves on the front of the camera.

having to take the camera too close to the subject. For the same reason they are often used with extension tubes for close-ups.

135 and 150 mm lenses

These are favourites with many photographers because they have the advantages of the 85 and 100 mm lenses and are also long enough to be suitable for taking sports subjects.

200, 400 and 1000 mm lenses

These are the really long focus lenses. They are used by the press at cricket and football matches, motor races and similar events where a shot of distant action is required.

They are also favoured by naturalists for taking shots of animals and birds from hides. Apart from such specialist uses they are not so frequently re-

quired as the shorter focal length lenses.

Zoom lens

The zoom lens is one in which the focal length is infinitely variable between the minimum and maximum of the lens. This means you can make the image larger or smaller without having to change the lens or your position. So one zoom lens can take the place of several lenses of fixed focal length. The design of such a lens involves complicated mechanical and optical problems and zoom lenses are more expensive than fixed focus lenses.

It is now possible to buy a zoom lens which extends from 28 mm to 200 mm – this covers the whole range needed by most photographers.

Mirror lens

One of the main disadvantages of the very long focus lens (500 mm and over) is its length and weight. This is overcome by the mirror lens which is built on the same principle as the reflecting telescope. As the light rays travel three times up and down the length of the lens barrel it can be much shorter than for a normal lens of the same focal length. Owing to the design of the lens it cannot incorporate an adjustable diaphragm and has to be used at a fixed aperture, usually $f8$.

Converters

Alternative lenses are costly and for those photographers who only require the use of other focal lengths on a few occasions, the converter is a cheap alternative. These do not give as good a performance as the original lens, but they can make possible a shot which could not otherwise be taken.

Teleconverter
The teleconverter magnifies the image formed by the camera lens. It is fitted between the body and the normal camera lens – so can only be used on SLRs. Converters usually give two or three times magnification of the image. A disadvantage is that the f number is multiplied by the same factor, so using a 2X converter $f8$ becomes $f16$ and using a 3X converter $f8$ becomes $f24$.

These converters work better with long focus lenses than with lenses of normal focal length.

Wide angle converter
The wide angle converter is of more complicated construction and less common. It screws on to the filter thread on the lens mount and a typical example converts a 50 mm lens to 20 mm focal length and a 35 mm lens to a fish-eye lens. This type of converter has no effect on the aperture of the lens.

Close-up lens

There are several methods by which a camera can be used at closer distances than the focal length of its lens would otherwise allow.

The simplest method is to use a close-up lens. This is fitted on the front of the camera lens and changes its focus. They are marked in dioptres (which are units used to express the power of a lens) and the most usual are 1, 2 and 3 dioptres. With a close-up lens fitted the focusing of the camera is changed (*see below*).

Effect of close-up lens on focusing

Camera lens set at infinity	1 dioptre lens is focused at 1 metre
	2 dioptre lens is focused at 50 centimetres
	3 dioptre lens is focused at 33 centimetres
Camera lens set at 1 metre	1 dioptre lens is focused at 50 centimetres
	2 dioptre lens is focused at 33 centimetres
	3 dioptre lens is focuces at 25 centimetres

Bellows can be fitted between the body of the camera and the lens to move the lens further away from the film and allow focusing on close-up subjects. Extension tubes work on the same principle. The longer the tube, the greater the magnification of the image.

Extension tubes

When you buy a close-up lens there will be included a table showing the distances at which the lens will be focused when it is set at the intervening distances on the scale. For most purposes it is better to work with either the infinity or one metre settings on the camera focusing, as these are easier to remember.

With a non-reflex camera the parallax error is increased at these close distances. For occasional use it is satisfactory to set the subject in line with the lens rather than using the viewfinder. If much close-up work is done you will want to know exactly what is included in the shot. This can be done by opening the camera back when there is no film in the camera and putting a piece of greaseproof paper along the film track. If the shutter is set at B and the shutter release pressed it

will be possible to see the image on the greaseproof paper and this can be compared with what is seen in the viewfinder.

A useful guide can be made by setting up a sheet of squared paper with the squares numbered and taking a shot of this, carefully noting which squares are visible in the viewfinder. By comparing this with the print you will have an accurate indication of the difference. Keep the sheet of paper and use it as a guide for placing subjects for close-ups. You will know that when the viewfinder is lined up on the upper rectangle, objects within the lower one will be covered by the lens.

When working at very close distances the depth of field is very shallow and it is therefore necessary to use a small stop – in most cases $f11$ or $f16$ is advisable.

Close-up tubes

Close-up work is much simpler with the single lens reflex type of camera because the subject can be focused in the viewfinder and there is no parallax problem.

With these cameras close-up lenses can be used and this is the simplest method of taking near subjects because the close-up lens has only to be screwed on to the camera lens and the camera can

The macro lens is specially designed to produce high quality close-up pictures. Its mount extends to allow closer focusing than a normal lens.

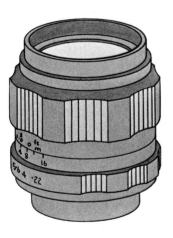

A close-up lens screws on to the front of the camera lens like a filter. Many different types are made which give different degrees of magnification.

then be used in the ordinary way.

However, with the single lens reflex there are other ways of extending the range. As was seen (*page 10*), the lens has to be moved further away from the film plane to focus on near subjects. This can be done on the SLR by using extension tubes or bellows. The camera lens is removed, the tube or bellows screwed on to the camera body, and the camera lens then fitted to the tube or bellows.

The tubes are usually in a set of three of different lengths, while the bellows allow for variable extension.

When either extension tubes or bellows are used the exposure has to be increased. With a camera with through the lens metering this is automatically compensated for. Users of other SLRs will find a table with the tubes giving details of the correction needed.

Close-up subjects
Close-up equipment opens up a new world of subjects and you will find many beautiful and interesting targets for your camera.

When taking close-up shots pay particular attention to the backgrounds. Although distant objects will be out of focus they may still form distracting shapes in the print. Where possible place a sheet of card behind the subject, or arrange it against the sky or some other simple background.

Owing to the very shallow depth of field when working at short distances, flat or shallow objects are the best subjects.

When the finished print shows an object much larger than life-size it will be found that many things which appear to the eye to be delicate are quite coarse.

Close-up pictures of man-made objects often reveal imperfections, but close-up shots of natural objects bring out even more perfection than is visible to the naked eye.

Subjects must be selected carefully because of the restricted depth of field. A daisy-like flower is more suitable than the deep trumpet of a daffodil.

You may aim to produce good illustrations from the natural history point of view, or to take pictures which show the delicate beauty of the subjects. Many flowers seen in close-up show beautifully regular arrangements of their petals or delicately curling stamens. Leaves reveal the tracery of their veins. Specimens should be carefully chosen, avoiding those which have been damaged by weather or insects.

It is easier to take these shots indoors where there is no wind to cause movement. If you work near a window it is possible to use daylight. In most cases the best lighting will be flat on the subject, but with 'hairy' things such as catkins, an against the light shot will show up the subject better. Experiment with a white card reflector to lighten the shadows.

A close-up lens is ideal for taking tiny subjects like insects.

This close-up of a cactus makes a fascinating puzzle picture.

Another puzzle – the bristles on a hairbrush.

A beautiful close-up of two flowers.

PROCESSING BLACK AND WHITE FILMS

If you do your own processing you add enormously to the interest of photography as a hobby and also have greater control over the results.

This chapter explains how to develop exposed film to produce black and white negatives. You can skip this stage and ask a reputable dealer to process the negatives for you and then go on to enlarge and print the picture yourself (*see page 128*). This is one way of having a say in the final result without having to do all the work yourself!

Before you start, it is very helpful to understand the chemistry of developing film.

As was previously explained on *page 12*, the image forming parts of the emulsion of a black and white film are the silver halides. These have the important property of being affected by light. There is no visible change in the emulsion after exposure to light but after the film is 'developed' in certain chemicals a negative image appears.

<div style="border:1px solid black; padding:4px;">

The chemistry of developing film

</div>

Remember – the chemicals described here must be used carefully. Never leave them where young children might reach them and always wash your hands carefully after you use them.

Developer
A photographic developer has four main constituents:

Developing agent: A chemical compound capable of changing the exposed grains of silver halide into black metallic silver, but having no appreciable effect on the unexposed grains in the emulsion.

There are a number of chemicals which will do this, but the most suitable for photographic use are hydroquinone and metol or phenidone. The former gives very contrasty results, while the latter gives softer results. You will find most developers contain both.

Alkali accelerator: Developing agents work best in an alkaline solution. The degree of alkalinity controls the quality of the negative. A low alkaline developer works slowly and produces a fine-grained negative. As the alkalinity increases the developer works more quickly and as a result the grain of the negative becomes coarser. In a fine grain developer, sodium borate could be used; while if a quicker developer is needed, sodium carbonate could be used.

Preservative: A solution containing developing agent and an alkali tends to oxidize and go brown, after which it ceases to be effective. To prevent this reaction a preservative is included. Sodium sulphite is frequently used for the purpose.

Restrainer: To prevent the developing agent from converting the halides which have not been affected by light, a restrainer is included. Potassium bromide is used.

Types of developer

There are many different developers aimed at producing special results and in these the quantities of the chemicals will vary, and other chemicals may be introduced. Modern photographers usually purchase ready mixed developers which are either in concentrated liquid or powder form. There are many varieties, which can be divided into four main groups.

Standard: The best to start with is either Kodak D-76 or Ilford ID11 – two old established developers which produce similar results.

Fine grain: These produce negatives with very fine grain which gives very fine detail. These can reduce the effective speed of the film.

High definition: These do not produce quite as fine grain as the fine grain developers, but they create an appearance of sharpness by what is termed the 'edge effect' – a build-up on the division between two tones, which in extreme cases almost gives an outline round the subjects.

Speed increasing: Some developers enable the film to be exposed at a higher ASA speed than their normal rating. This is useful for action pictures on dull days.

Stop bath

When development is complete, the action must be stopped as quickly as possible. The simplest way to do this is to use an acid solution – a dilute solution of acetic acid is the most common form of stop bath.

Fixer

After the stop bath stage the emulsion holds a mixture of metallic silver and untouched silver halides – which could still be affected by light. To remove the halides the film is put in a solution of sodium (or ammonium) thiosulphate, commonly known as hypo. The fixer – as the solution is called – may also have potassium metabisulphate added to stop the developer action and to prevent staining.

Washing

Finally the film is washed to remove unwanted silver halides and any chemicals remaining in it.

The film now has a negative image formed of minute grains of silver. These appear black because the grains are so small that they do not reflect any light.

Equipment needed

As well as the chemicals mentioned above, you need various pieces of equipment to develop your own film.

The process of development must be carried out in complete darkness. Most workers develop film in a lightproof tank, and so complete darkness is only needed for loading the tank. If a darkroom is not available for this it can be done after dark in any room with thick curtains which keep out street lights. Work well away from any doors which may leak light.

Alternatively a changing bag can be used. This is a bag of light-tight material with two sleeves projecting, through which the arms can be pushed. The bag is a useful possession as it can also be used to clear a film which is jammed in the camera.

Developing tank

A developing tank is a light-tight container with a central hole through which solutions can be poured. Inside it has a spiral reel on to which the film is wound and held so that the layers of film do not touch and processing chemicals can circulate freely. With most tanks the film is wound on with a ratchet motion after the leading end has been fed in. This is usually a trouble free operation, but as it has to be done in darkness it is a good idea to practise with an odd end of film or an out-of-date film. It is possible to buy daylight loading tanks, but unfortunately they are usually rather expensive.

Equipment and chemicals needed for developing a film

Key
1. Funnel
2. Clock with second hand
3. Developing tank
4. Thermometer
5. 3 measures
6. Plastic bowl
7. Container for stock solution of fixer
8. Bottle for stock solution of developer
9. Stop bath – bought as concentrated liquid
10. Changing bag
11. Fixer – bought as powder
12. Developer – bought as powder
13. Film clips
14. Film wiper
15. Hose to wash film
16. Scissors

Key to following pages
White background – safe to work in daylight/electric light.
Orange background – must use orange safelight.
Blue background – must work in complete darkness.

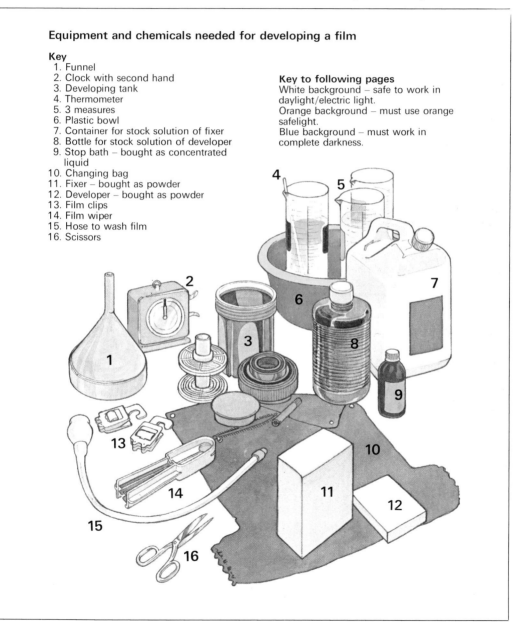

Measures

To measure the quantities of chemicals needed, three measures, each holding the quantity needed for the tank (usually around 300 cubic centimetres), are required. These should be of glass or a plastic resistant to photographic chemicals. mark these D, S and F for developer, stop bath and fixer, so that you will know which each contains.

Thermometer

Film developing times vary with the temperature, so an accurate thermometer is needed. Photographic thermometers usually read between 13 and 30°C and have wide spaced markings for easy reading.

Clock or watch

A clock or watch with a second hand is needed. A darkroom clock has seconds round the outer dial and minutes on a small dial. It is set at zero when starting so the exact amount of time elapsed can be easily read.

Film washing facilities

To ensure adequate washing of the film have a rubber tube that can be attached to a cold tap and pushed into the central tube of the developing tank. (The tube from a hair rinse spray can be used if detached from the rest of the fitting.)

Film clips

When processing is complete the

If developer and fixer are bought in powder form, prepare stock solutions according to maker's instructions. Remember all these chemicals should be kept out of the reach of young children.

Pour the stock solutions into labelled containers. Developer must be stored in full, airtight bottles. Make sure each solution is kept completely separate and wash your hands after working.

This is what a developing tank looks like. Inside the tank is a reel. Always make sure the tank and reel are completely clean and dry before you use them.

Take the reel out of the developing tank and, if necessary, adjust it to fit the size of film you are developing. (We are only talking about developing 35 mm film.)

film is hung up to dry. Ordinary clips hold water and may slip. Special film clips have prongs which grip the film. (If you use bulldog clips for your first efforts, use the largest variety and insert a piece of newspaper in the jaws to soak up any water.)

Film wiper
A film wiper with two arms with rubber blades is used to wipe the film and remove droplets of water which, when dry, would mark the surface.

A step-by-step guide

The secret of successful processing is to be methodical and to follow a set routine. It may be tempting to try new developers or to alter the procedure, but it is better to stay with one developer till you achieve success. Study this guide very carefully before you begin.

Developing negatives should not make a mess, but if you have not got a darkroom it is safer to work in a room without a carpet unless it is protected with a plastic sheet. The kitchen is a good place, as water is available and it is usually warm which makes it easier to keep the temperature of the solutions right.

Before starting make sure you assemble all the required equipment and chemicals.

Take the developing tank, exposed film and scissors to the darkroom (or use a changing bag). Trim off the film leader.

From now on you must work in complete darkness. Lever off the top of the cassette. (You may need something like a bottle opener to do this.)

Handling the film very carefully by the edges, feed it into the reel from the developing tank following the natural curl of the film.

Push the film in until it passes the two ball bearings, then feed it all in by rotating the two halves of the reel backwards and forwards.

When the end of the film is reached, cut from the spool. Place the reel in the developing tank.

Put the water-tight lid of the developing tank on firmly. Do not take off the lid until the film is fixed. (Chemicals are poured in and out through a hole in the lid which is covered by a removable cap.)

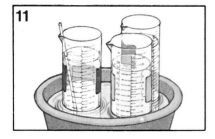

You can now work in ordinary lighting. Prepare in the 3 measures the required quantities of working strength developer, stop and fixer at 20°C. If necessary, stand the tank and the measures in a dish of water at about 21°C.

Remove the water-tight cap on the lid of the tank and pour the measured amount of developer in. Replace the cap and agitate the tank vigorously for about 15 seconds.

Continue to agitate at intervals as instructed by the makers of the developer you use. After about 2 minutes check that the temperature of the developer is still 20°C.

Begin pouring off the developer about 10 seconds before the end of the recommended developing time. Most modern developers can only be used once, so pour the developer away.

Pour the measured amount of stop bath into the tank and then agitate the tank gently for about one minute.

You can agitate by gently shaking the developing tank or by using a mixing rod which fits through the hole in the lid. After one minute pour the stop bath back into its container. You can re-use it.

Pour the measured amount of fixer into the tank. Agitate for 10 seconds and then again for 10 seconds every minute.

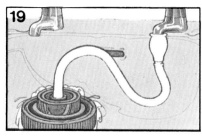

After 4 to 5 minutes take off the lid and examine the film. If it shows any milkiness replace the lid and continue fixing for another 2 to 3 minutes. Pour off the fixer – it is not really worth trying to re-use it.

Place the tank in a sink and run cold (but not very cold) water gently into it with a rubber hose connecting the tap to the central hole in the lid. Keep the water running gently over the rim of the tank for 30 minutes.

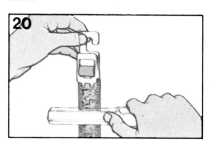

Attach a clip to the end of the film and gently ease it off the reel taking care not to touch or knock it. Remove any water droplets with a film wiper.

Hang the film to dry in a dust-free place for several hours. Put a clip on the bottom, too, to stop it curling up. Remember to wash out the developing tank and leave to dry in a dust-free place.

Negatives are delicate. They should always be handled by the edges. 35 mm negatives are best cut into strips of 6 and filed in a negative file.

Making a print from your negative is one of the most rewarding processes in photography. You can select the picture area exactly and control the result – and enlarge your best pictures to produce satisfying results.

A darkroom

A darkroom is needed for making prints. In winter if you only want to work at night almost any room will do, but in summer it is preferable to have a room with small windows because these are easier to black out. The kitchen or bathroom are favourites because running water is available, but many photographers manage without this. In some old houses there is a cellar or cupboard under the stairs which can be used.

A good arrangement is to use a cupboard as a storeplace with the enlarger mounted on a shelf and a small table outside for developing. A more permanent darkroom can be made by partitioning off a section of a room with hardboard on a light wooden framework. A space 1·25 × 2 metres is adequate.

Windows can be blacked out with sheeting obtainable from photographic dealers. For a small window a sheet of hardboard held in place by turn-buttons can be used.

Two working areas are needed, 'dry' and 'wet', and these should be kept well apart. The dry area will have the enlarger, and the wet area will have the dishes with the processing solutions.

Safelight
The first essential in the darkroom is a safelight so that you can see what you are doing without fogging the material. For making bromide (*see page 130*) prints an orange safelight is required. Follow instructions as to the wattage of bulb to be used and the safe working distance.

White light
It is not possible to judge the tones of the prints properly in the light of the safelight. A desk lamp or bedside light with a surround of cardboard is suitable. Remember *never* touch the light switches with wet hands.

Dishes
You need three dishes big enough to take the size of paper you are using. If you get different coloured dishes it is easy to make sure that you keep one for developer, one for stop bath and one for fixer. In addition have a bowl or bucket in which fixed prints can be placed in water till the session is finished. Keep all the dishes free from dust.

Print tongs
To avoid contaminating solutions print tongs are used to transfer the paper from one solution to the next.

Dishwarmer
In winter when it is difficult to

Enlarger

The enlarger is the most important piece of equipment for printing photographs. It has a light which shines through the negative so that an image is projected on the baseboard. Always keep the enlarger covered when not in use.

lamphouse

condensers — 2 large lenses arranged to spread light evenly over the negative

filter drawer — this enlarger can be adapted for colour printing by putting filters into a drawer between the condensers and the negative

negative carrier

lens — this is mounted so that it can be moved to focus the image

red swing filter

focusing control

enlarger column — the enlarger head is moved up and down the column to adjust the size of the image on the baseboard

paper easel — used to hold the paper on the baseboard of the enlarger (some types have a frame which clamps the paper and gives prints a white margin; others produce borderless prints)

keep up the temperature of the solutions a dishwarmer is useful.

Focus finder

Some negatives have detail which makes focusing the enlarger easy, others have no definite lines. The focus finder or magnifier reflects a section of the projected image which is viewed through a magnifying system. By focusing on this sharpness is assured.

Additional equipment

If you have processed your own negatives you will already have this equipment. If not, check *page 122* and note that you need three measurers and a thermometer. You also need a sponge.

Paper

For making prints *bromide* paper is used. This is paper coated with an emulsion containing silver bromide, which is much slower to react to light than the emulsion used on films. As with films a latent image is produced on exposure to light and this is made visible by development.

Bromide paper is made in grades one to five. Most negatives can be printed on grade two or three paper, but the other grades offer a choice which may be more suitable for some subjects. A scene on a dull day can be made brighter by using the more contrasty grade four or five papers;

MAKING CONTACT PRINTS

It is best to start by making a sheet of small 'contact' prints. Then you can choose the photographs which will look good enlarged.

In the darkroom, as far away from the safelight as possible, take out a sheet of 203 × 254 mm bromide paper. Close the packet. Put the piece of paper shiny side up on the baseboard of the enlarger.

Make sure the enlarger lens is covered by its red safety filter then turn on the enlarger light. Adjust enlarger height until the light covers an area roughly 210 × 270 mm. Stop down to *f*8.

Place strips of exposed film in rows, emulsion (dull) side down on top of the paper. Cover them with a piece of clean, unscratched glass.

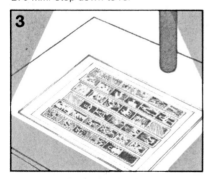

Swing the red safety filter away from the enlarger lens for $7\frac{1}{2}$ seconds. The photographic paper will now need to be processed as explained on page 133 onwards.

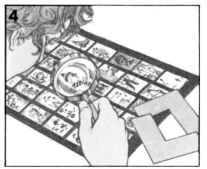

If the resulting contact prints are too dark, repeat the process reducing the exposure time. If they are too light, increase it. Look carefully at the contact prints and make enlargements of the most attractive.

while the softer grade one will help to reduce the contrast of subjects on brilliant sunny days. Bromide paper is supplied in various surfaces – matt, velvet, glossy etc. It is best to start with grade two, glossy paper 165 × 216 mm. Later you may decide to try out some of the other surfaces.

Ordinary bromide paper requires a long washing time to remove the chemicals from the paper base and, after washing, it takes a long time to dry. These problems are overcome with resin coated (RC) paper. This is coated with a thin layer of plastic substance which does not absorb chemicals so that washing and drying times are reduced. The coating produces a high gloss without glazing and makes the

ENLARGING: MAKING A TEST STRIP

To work out the correct exposure time for a print from a negative you need to make a test print on a small strip of paper.

Insert the chosen negative into the negative carrier of the enlarger, shiny side upwards.

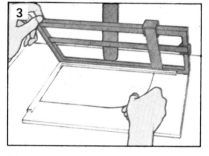

Close the negative carrier and place in the enlarger. (Remember – handle negatives by the edge only and remove any dust specks with a camel-hair brush.)

Place a sheet of plain white paper in the easel underneath the masking frame which should be adjusted to the size you want the final print to be. Turn off the lights and turn on the safelight.

Having set the lens at its widest aperture, switch the enlarger light on. Move the enlarger head up the column to make the image on the easel larger or downwards to make it smaller. When the size is right, turn the focus control to make the image sharp.

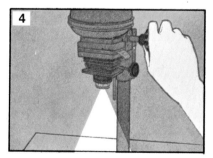

Adjusting the focusing alters the size of the image, so move the enlarger head to retain the correct size. Check the focusing with the focus finder. Turn the enlarger light off and set the aperture at f8.

paper dry flatter than normal paper.

Developer

Special developers are prepared for printing papers. Kodak D-163 or Ilford Bromophen are two basic developers which can be used to start. Follow the instructions with the developers as to dilution and development time. Like negative developers these should be kept in full, well-stoppered bottles and should be handled with care.

Stop bath and fixer

The same stop bath and fixer needed for processing negatives can be used.

Remove the sheet of plain paper and place a narrow strip (about 5 cm wide) of grade 2 paper in the easel, shiny side up. Make sure this is held by the masking frame.

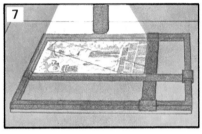

Switch on the enlarger light and expose the whole strip for 5 seconds.

Then cover $\frac{1}{4}$ of the test strip with a piece of card. Move the card at 5 second intervals so that the quarters of the paper have exposures of 5, 10, 15 and 20 seconds.

To judge the results you must develop the test strip as shown on the next few pages.

Examine the print and judge which exposure time gives the best result. If the whole strip is too dark, repeat the process with the aperture of the enlarger lens at f16. If the whole strip is too light, try exposure times of 25, 30, 35 and 40 seconds.

Put a sheet of grade 2 paper into the easel and make a complete print to the best time suggested by the test strip. The size of the image and the aperture should be the same as for the test strip. Your print is now ready to develop. Do not expose it to light or it will be spoilt.

Developing prints

To develop prints you need three different chemicals just as you do to develop film. These are: print developer, stop bath and fixer. If you have already bought stop bath and fixer to develop your film, you can use these again to develop prints. You should, however, buy print developer rather than using film developer.

Prepare these chemicals according to the manufacturer's instructions on the bottle or packet and put in labelled containers. Developer must be stored in full, airtight bottles.

Make sure each solution is kept completely separate and wash your hands after working with them. Keep out of the reach of young children.

These chemicals must be used at the correct temperature. Check the manufacturer's instructions as to what this is – usually 20°C. If necessary take a bowl of warm water into the darkroom to stand the measures in. In very cold weather you may need to stand the developing dishes on a dish-warmer.

Retouching

If you have been careful to keep the negative and enlarger clean there should be no need for retouching. If there are white marks, these can be filled by applying retouching dye with a small sable brush. Dilute the dye till it matches the area surrounding the spot and then apply it with a nearly dry brush. Practise first on spots in dark areas of the print where the retouching shows less than in areas of even light tone.

How to arrange equipment for developing prints

In the darkroom, mix diluted solutions of the chemicals and pour them into marked dishes. You must not mix the chemicals so use different tongs to move the paper from dish to dish.

clock

measure

thermometer

tray

tongs

Turn out the electric light and put the safelight on. Slide the exposed paper, shiny side down, into the developer.

Rock the dish gently for 20 seconds, then turn the paper over (use tongs). Continue rocking until the recommended developing time has elapsed.

Remove the print, allowing it to drain for 2 or 3 seconds by holding it above the dish with the tongs.

Next put the print in the stop bath and rock gently for about 15 seconds. Then transfer it to the fixer. Keep rocking the fixer dish gently.

After the print has been in the fixer for 2 minutes, it is safe to turn on the light. Make sure your hands are dry before touching the light switch. Leave the print in the fixer for 5 to 10 minutes.

When fixing is finished, take the print to the sink and wash it in running water for about 30 minutes. Keep it in the dish while it is being washed.

Drain the print and lay it to dry on blotting paper. Wipe the surface with a sponge to avoid drying marks.

Don't use an even brush stroke – but use a 'spotting' technique, adding tiny points of dye.

Special printing effects

Vignetting
If the background of a picture is distracting it can be eliminated by vignetting. Cut a circular or oval hole smaller than the subject in a piece of card. Hold the card between the lens and paper during the exposure, moving it continually up and down to produce a soft edge. This was a device used in early portraiture.

Texture screens
Texture screens add an all-over

linen, etc., indicate the effect they produce.

Multi-image

Where there is one single prominent subject in the negative, a striking print can sometimes be made by printing the subject several times on the same piece of paper. The images could be the same size and arranged in a pattern, or could be arranged in a receding series of different sizes. Draw the proposed arrangement on a piece of paper and use this to position the printing paper between exposures.

△ A vignette gives an unusual effect.

pattern to the print. There are two types, one which is placed with the negative in the negative holder, and the other which is placed in contact with the paper. Their names, hessian, gravel,

Combined negatives

The most common use of combining negatives is to print a sky from another negative on to a print which has no clouds in it. First make a print of the land-

IMPROVING PRINTS

Exposure must be accurate to produce a full-toned print. Err if anything on the side of underexposure. If the print is too contrasty, with dense shadows and no detail in white areas, make another print on grade 1 paper. If the print is grey and lacks contrast, try a grade 3 paper. If the print is generally satisfactory except for isolated areas you need to vary the exposure in these patches.

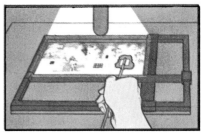

If the shadow areas in a print are too dense they can be shaded during part of the exposure. Use a piece of card, cut roughly to shape, on a piece of wire. Keep it moving very slightly.

If there is no detail in the sky or pale areas this can be added by extra exposure (burning in). Do this by shading the rest of the picture. Keep the card moving to avoid a hard edge.

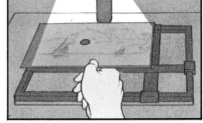

Isolated pale areas can be darkened by allowing the light to shine on to them, through a hole in a piece of card, for a few seconds over the set exposure time. Keep the card moving to avoid a hard edge.

This image was exposed many times to make this pattern.

scape negative; then, after marking the top edge, remove the paper and put it in a safe place. Place a piece of white paper in the enlarging easel and draw the sky line in from the first negative. Replace the negative with the sky negative and focus this to fill the sky area as marked. Make a test strip to find the required exposure for the sky. Then put the first print back on the easel and print in the sky, shading the lower part of the print. When this is developed the print will have the sky over the landscape.

Monochrome colour effects

A black and white print is very attractive, but some people like to change the image into another colour. This is a process which is only suitable for a few subjects.

There are two types of process – chemical and dye toners:

Chemical toners: In some processes the silver image is first bleached and then put into a second bath which produces the coloured image. In other processes only one bath is used.

Brown, red, yellow, blue and green tones can be obtained in this way.

Dye toners: Some modern toners use dyes. The print is bleached and converted into a form which makes it able to take up dyes. After washing it is put in the dye bath.

A wider range of colours can be obtained by this method, including violet and orange.

Coloured base: A colour effect can also be obtained by making prints on coloured bases instead of white paper. These can be obtained in various colours and also with a metallic effect. A similar result can be obtained using dyes which colour the base.

With this type of print the image is black on a coloured background.

Photograms

Photograms or shadow pictures are photographs taken without a camera. You can use various objects – such as leaves, grasses, lace, pins, etc. – to make original and interesting pictures and patterns.

In a dark room take an attractively shaped leaf, for example, and place it on a piece

A photogram is very simple to make.

Sketching from prints can produce impressive pictures even from those of us who are not very good at drawing!

of the light sensitive paper you use for printing your photographs. Cover with a sheet of glass and put under a desk lamp fitted with a 275 watt No. 1 Photoflood Lamp. Set the light about a metre above the paper, and switch on the lamp for about 20 seconds.

Then develop the paper in the same way as you develop a print – using developer and fixer and washing (*see page 133*).

You can adjust the exposure time to get different effects.

Sketches from print

This is a method of making pen and ink sketches from black and white photographs which is at times used by commercial artists.

Make a print of the chosen subject on matt paper as this gives a more authentic appearance to the finished drawing. A weak flat print should be made for the purpose, but it is useful to have a well-toned print as a guide.

With a fine pen and waterproof Indian ink draw in the outline of the objects in the photograph with any detail you wish to include. Think of how the result will look as a drawing and do not make the linework too mechanical. Omit anything you wish to leave out, such as unwanted figures or traffic in a street. Do not hurry this stage or the final result will be spoiled.

When you have completed the outline allow the ink to dry. Then bleach out the photographic image with the following solution:

Iodine (10% solution) 20 cc
Thiocarbamide (10%
 solution) 40 cc
Water 40 cc

(A chemist will make up the iodine and thiocarbamide solutions.)

When the photographic image has completely disappeared, fix the print in 'hypo' (*see page 122*) and wash for 30 minutes. Do not touch the ink while the print is wet. After it has dried, the pen and ink work can be completed with shading and cross hatching. Keep this simple, for the fewer lines the better the effect.

A montage is always great fun to produce.

Montages

Montages are a way of producing pictures of things that never happened or could never happen.

The process consists of combining two or more prints by cutting out a portion of one and pasting it on to another. In this way you could make a photograph showing a lion walking down your street, or of a china pig 'flying' over the park.

To be successful the lighting in both the prints should be consistent and they should be taken from the same angle. Often one print will suggest the idea and you can then take a shot to match in with it. If you have a shot of someone digging in the garden you could take a shot of a pie, and then paste a cut out print of the digger on to a print of the pie.

The paste-up should be done on a large print – say 203 × 254 millimetres, then when completed it can be copied and postcard, or 165 × 216 millimetres, prints made on which the paste-up will not be visible. The cutting out should be done carefully with a sharp, pointed knife or craft cutter and if the back is sandpapered at the edges, the joints will be less noticeable.

It is helpful to sketch out the idea first, as a guide to taking the shots and making the prints. Often a simple change of scale is all that is needed to make a striking picture – put a pony-riding friend astride a piggy bank or have a model dinosaur walking down the garden path!

USING YOUR PHOTOGRAPHS

Photographs have a vast number of uses – the chief probably being to give pleasure. They are wonderful reminders of things you have seen and done.

Albums

Many amateur photographers who spend a great deal of time in taking their photographs lose much of the pleasure the prints should bring because the photographs are put away in drawers and very rarely looked at. A good photograph deserves to be well looked after and kept where it can be found.

If prints are merely put into an album as they are taken, after a year or two you will have several albums with jumbles of prints and it will be just as difficult to find them as if they were in a drawer. Plan your album as if you were making a book – or rather a series of books. Have a separate album for each topic on which you have a number of pictures.

An album gains value with the years. One weather observer in England took pictures of the same clumps of flowers and tree branches on the same date for 30 years. This made a fascinating record of the variations in the weather and was published as a book.

Think carefully as you start your albums. If you begin in a haphazard fashion it is very difficult to rearrange them later.

An album is much more interesting if you take a little extra care in arranging the prints. In the holiday album, treat each holiday as a chapter with a separate title page and perhaps a map. Vary the size of the prints and arrange them in different ways, rather than setting them all out in formal rows.

Ready-made albums are costly and only have a limited capacity. Loose-leaf binders with sheets of coloured paper make an album which will hold many more prints and allow you to lay things out well. Office stationers sell punches which will accurately punch the holes to put the sheets into the binders. A packet of reinforcements to stick round the holes will prevent them being torn by constant turning.

Careful lettering in coloured ink will give the pages a tidy appearance – longer captions could be typed on slips and pasted in.

Collecting with a camera

Collecting is one of the most popular hobbies, but you are limited as to the subjects for a collection by the price and size of the items. By using your camera you can collect anything from castles to cars.

In taking photographs for a collection the aim should be to make a true and accurate record. This calls for a different approach to that taken when trying to make striking pictures, but it is no less difficult.

If you are 'collecting' large objects – like castles – you first want a general shot which shows the castle with its surrondings. Next try for a variety of shots which bring out the special features of the structure – is it a castle on a hill? One that has a moat and drawbridge? One with a high tower?

If you decide to collect smaller articles you will have other problems. You may have to use your camera with a close-up lens and to arrange lighting to show off the special features. Museums and other collectors may agree to let you take shots of items in their collections – show them the album of prints you have compiled so that they know you are serious.

A well arranged album can be as interesting as any collection. Captions must be accurate and complete – typed slips look very tidy and efficient.

Displays

The best photographs deserve to be seen. Even those in an album may not be looked at very often. If you make your own enlargements your best photographs can be framed or mounted on stiff card and used to decorate walls.

Even small prints make a good display if several are mounted together in a panel.

An unusual method of displaying prints which looks very attractive is to trim them to a square shape, when they can be mounted together like tiles on hardboard. Either mount the prints flush with each other or allow a narrow margin. This should be marked in white or black. Colour the 'margins' first, allowing a little extra width, then when the prints are stuck on there will be no gaps or marks on the prints. Use a rubber type adhesive and the prints will be held firmly, but it will be possible to peel them off if required.

A panel of close-ups of flowers looks most effective. Sort them according to their colours then make a pattern with the colours. From a distance it will look like a colourful pattern, and on close inspection it will be seen to include all the flowers of the

DRY MOUNTING

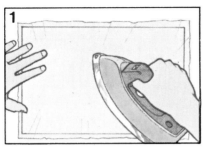

To dry mount you need to buy sheets of special tissue. A sheet is tacked to the back of the print using a warm iron. Do the centre then the corners.

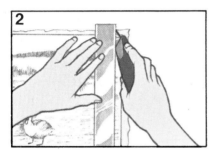

Then trim the print and tissue carefully so that they match exactly.

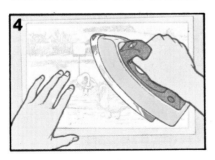

Put the print on to a piece of mounting board. Peel back the corners and tack the tissue with the iron to fix it to the mount.

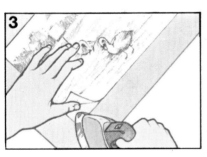

Put a piece of thin card or tissue paper over the print and apply firm pressure with the iron from the centre.

garden. A panel made in this way would brighten a dark corner.

Greeting cards

Choosing birthday and Christmas cards is always difficult, and the best ones are costly. Making your own cards means that you have a supply on hand and they can be more personal.

Mounts for cards can be bought from photographic dealers, but these usually take the print inside, which is suitable for a portrait, but not for a greetings card which should have a bright picture on the front. Make your own mounts by cutting a piece of card double the size of the print. Then fix your print to the right hand side of the mount and fold it over to finish the card.

Do not try to compete with the type of pictures used on professional cards, but find something more personal. A keen gardener would be pleased with a card showing a view of her

garden; a footballer would like a shot of himself in action; another relative might appreciate a picture of you and your family. For Christmas cards you could use a shot taken in your area during the snow of the previous winter.

Competitions

A good way of finding out how good your photographs are is by entering them in competitions. Winning a prize is a sign that you are on the right lines.

Every year there are many competitions organized by the makers of various products and by magazines. Don't be one of those irritating people who say they have a better picture than the one which won the prize – but didn't enter.

Tear out details of all the competitions you see announced and study them carefully. Note the subject, the closing date, the type and size of print required and whether a coupon or pack of the product is needed.

Many people send off any print which they think is good without considering if it is suitable. Keep a sheet of paper for each competition and jot down any ideas for pictures. If it is for 'Happy Holidays', remember that holidays include the journey, arriving at your holiday accommodation and playing games. If the competition is run by a holiday resort they will not want a picture of rain on holiday, but a newspaper might take one.

An enlargement has a better chance than a tiny print. Read the rules and follow them carefully, then send off the print before the closing date and get on with the next competition.

Slide shows

The colour transparencies produced on 35 mm colour reversal film are brilliant gems in miniature. When studied in a viewer the colours glow. To see them properly, however, they should be projected on to a screen. Then at a metre or more wide they show the original scene in all its beauty.

The projector
A projector consists of a light source; a condenser to ensure an even spread of light; a holder for the transparency; and the projection lens which throws the image on to the screen. In modern projectors high powered lamps are used and as these generate considerable heat it is usual, for safety purposes, to include a heat absorbing glass between the light and the slide.

The simplest projectors have a slide carrier which accommodates two slides and is shuttled from left to right and then from right to left so that while the slide in one holder is being projected the other can be changed.

The first step up in the range is the semi-automatic projector in which the slides are stored in a magazine and the operator moves the transport arm to return the last slide to the magazine and insert the next one for projection.

On fully automatic projectors the changing of the slides is done by pressing a hand control button, which can be at a distance from the projector.

The higher priced projectors are equipped with more powerful lamps and more efficient optical systems so that they can project

pictures over a greater distance and to a larger size.

In choosing a projector consider the use which it will be given. There is no point in having a projector which would be suitable for a large hall if it is going to be used most of the time only for family gatherings in an ordinary room.

The screen

Equally as important as the projector is the screen. Unless this has good reflective power and is free from blemishes the slides will not be seen at their best. The cheapest screens have a white surface, while a silver surfaced screen which is more reflective costs more. Some screens, covered with glass beads, have a high reflective power, but can only be viewed from a narrow angle so that they are not suitable for home use.

Projector and screen

There are many different types of projector available. The cheaper ones are operated by hand. More advanced models can change the slide by remote control and focus automatically.

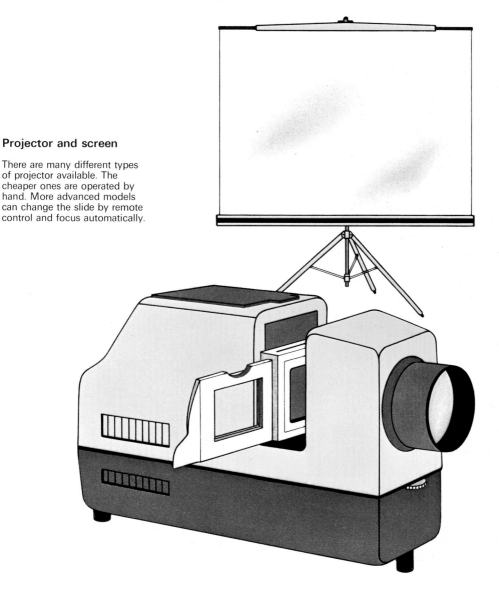

A slide show

Preparing a slide show is like making a cine film and needs planning from the very start – the taking of the pictures. They should have a sequence and should tell the story with the need for only short explanations. Remember that the audience will only know what you show them, so it is necessary to include general as well as detailed shots.

A section of a slide show covering a village could begin with a distant view. Next would come the approach along the road with a picture of the nameboard by the roadside so that the audience know where the scene is. Then would come a shot of the main street and finally the camera would pick out the best buildings and show some of their features.

To make a good show you have to take many more transparencies than if you were merely looking for isolated 'good' pictures, because you are telling a story. Of course, you should aim at making every one of good quality.

When the scene moves from one place to another, or from one day to the next, make sure that the audience realizes the move by including one or two pictures of the journey and the approach to the next place.

Shots of maps and plans will make it easier for those who do not know the area to follow the journey – the route could be shown by a gradually lengthening line marked on a map.

At home some of the gaps can be filled with shots of souvenirs, shells, rocks or postcards.

Number the slides in the order they will be shown and put them in a box. Draw a line diagonally across the top edges – then if one gets out of order it is easy to notice it.

Prepare an interesting commentary with a separate sheet for each slide. Check up on any figures or dates which are included. Try to lead from slide to slide so that it seems to be a complete show rather than a series of separate pictures.

Careful preparation beforehand will ensure that the show is a success. Decide where the projector and screen will be, and arrange the chairs and settee so that everyone will be able to see comfortably. The screen should be set in a dark place so that light does not spoil the pictures, and the projector should be level with

Store slides carefully in boxes. Mark them so that it is easy to keep them in the correct order and load them the right way round.

the centre of the screen – if it is pointing upwards the pictures will be distorted unless the screen is set at the same angle.

If you are using a manual projector it is useful to have a projectionist so that you can concentrate on the commentary.

As a precaution, have a spare bulb ready for the projector!

Photographic clubs

There are photographic clubs in many areas where members get together to discuss their photographs, swap ideas and invite speakers on different subjects. Some clubs are lucky enough to have darkroom facilities. It is an enormous help to belong to such a group if you are an enthusiastic young photographer. Older members can give advice and encouragement and members will help each other out – sharing expensive equipment, paper etc. The address of your local photographic club can probably be obtained from one of the photographic dealers in your area. If there is no group near you or you are too young to join – why not try and start your own small club among your friends or at school?

Commercial and scientific uses

Most people think of photography as a hobby but there are some who earn their living with the camera. Photography is a combination of science and art. Possession of the right certificates will get you a position as a technician, but if you are to make further progress you need to be an artist and 'see' good pictures.

Education
Photography can be studied and examinations in it taken at some schools where facilities exist. More advanced courses are available at some Polytechnics and Schools of Art.

Photography is essentially a practical business and in many firms entrance is as a darkroom assistant, working up to camera operator when experience is gained and the right opportunity occurs.

Studios
In studios the emphasis is more on actual photography than in most other forms of photographic employment. In most towns there are studios doing wedding and portrait work and some of these also do commercial, industrial and advertising photography. The latter is one of the most highly paid branches because the standards are very high. The results also play an extremely important part in the success of the advertising campaigns.

▽ A commercial photographer at work in a studio.

Press

The work of the press photographer has been glamorized so that he or she is often thought of as a highly romantic figure. However, the majority of jobs are with local newspapers and the photographers have a mundane life covering local events and prize presentations at schools and shows.

Even for the photographer with one of the national newspapers there are dull assignments which mean standing in the rain for hours waiting for some prominent politician to emerge. However, the press photographer also meets film stars and other famous people and may be called in the middle of the night to fly halfway round the world to cover a revolution. On such jobs success depends as much on the ability to get the picture and ensure that it reaches the newspaper's office as quickly as possible, as on photographic skill.

Other applications

There are photographers in the police force who have to take shots of the 'scene of the crime', clues, weapons, wounds on bodies and finger prints. The police photographer is also called on to take identity pictures – the familiar 'mug shots'.

In hospitals medical photographers record the progress of treatments and experiments as well as preparing slides for teaching purposes.

Many institutions and firms engaged in building and engineering employ staff photographers who record the progress of the work and take shots for advertising and publicity.

Aerial photography is a spec-ialized branch of photography which has become widely used by map makers. Prints from aerial shots are compared with existing maps in a special camera viewer which reveals any changes so that they can be confirmed by a ground survey.

Aerial surveys often show up ground markings or colour variations in crops which indicate buried remains of interest to archaeologists.

 Press photographers at work.

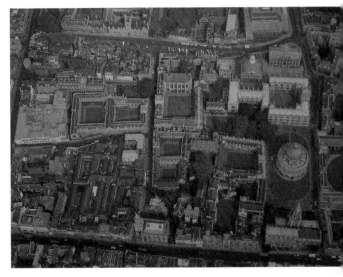

An aerial shot.

FAULT-FINDER

The taking and processing of photographs includes so many operations that there are very many reasons why mistakes can occur! Don't just throw bad pictures away. Find out the cause of the errors and make sure that they don't happen again. Here is a list of some of the most frequent causes of failures:

FAULT: No picture.
Cause: Faulty loading. Most likely with 35 mm when it could be due to the sprocket holes in the film tearing or failing to engage. When loading the film always wind it on until both lines of holes are engaging with the sprockets. When winding on watch that the rewind knob rotates, indicating that the film is actually moving. If the film jams and a darkroom is available it may be possible to ease the film forward so that undamaged sprocket holes are engaged and the film travels properly. Look for the pieces of torn film inside the camera body when the film is unloaded.
Cause: Lens cap left on. Possible on non-SLR cameras where the metering aperture is not covered by the lens cap.
Cause: Battery dead. Some cameras have a small battery to work the light meter. The type of battery used is specially designed so that they do not gradually weaken (which would cause wrong exposures) but 'die' suddenly with no warning. Change the battery once a year. A small label, with the date of the battery change, stuck on the camera is a good reminder.

FAULT: Frames overlapping.
Cause: Having a finger on the rewind button when winding on the film.

FAULT: Two sets of pictures on one film.
Cause: Due to re-using an exposed 35 mm film. When an exposed film is removed from the camera, tear or twist the leader to indicate that it has been exposed.

FAULT: Obstructions in picture.
Cause: Parallax. Remember when taking distant objects that the parallax markings still apply to nearby objects – fences, trees etc. near the camera – and these must be watched.
Cause: Flap of ever-ready case. This is a well-known offender and the reason why many experienced photographers never use an ever-ready case.
Cause: Finger over lens. Make a habit of holding the camera securely with your fingers well out of the way of the lens. Most likely to be a problem with very small cameras.

FAULT: Pictures unsharp.
Cause: If the picture is unsharp all over it is probably caused by camera shake – usually a vertical movement. Enlarger shake is another possibility if you do your own printing.
Cause: If either the near or far objects are sharp but the rest of the picture is blurred, too large an aperture was used, resulting in insufficient depth of field.
Cause: A blurred subject is due to incorrect focusing.

Cause: A blurred moving object (when you don't want it to be blurred!) means too slow a shutter speed was use.

Cause: If the whole picture is blurred and lacking in contrast the lens may be dirty or misty from condensation.

FAULT: Prints dark and muddy. Slides too dark.

Cause: Underexposure. With a simple camera, prints will be underexposed if the lighting conditions are poor because you cannot allow for this. With a more sophisticated camera, underexposure will be due to having too small an aperture or too fast a shutter speed for the lighting conditions. On an automatic camera the film speed dial may be wrongly set.

FAULT: Prints washed out and contrasty. Slides too light.

Cause: Overexposure. Too much light has been allowed to reach the film. This could be due to an obstruction over the meter window or something shading it. In an automatic camera the film speed dial may be set wrongly. Otherwise you will be using too large an aperture or too low a shutter speed for the lighting conditions.

FAULT: Blemishes.

Cause: Dark areas or streaks are caused by light fog due to loading film in too bright a light or to the back of the camera being loose.

Cause: Straight lines along negatives are due to scratches from the cassette or film track or caused when wiping black and white negatives.

Cause: Dark spots on prints are caused by dust in the camera. White spots are caused by dust when printing.

THE HISTORY OF PHOTOGRAPHY

Probably few inventions have had a longer period of development than photography. In the 4th century BC Aristotle, the Greek philosopher, observed how an image of the partially eclipsed sun was projected on to the ground through the holes of a sieve and the leaves of a tree. He also noticed that the smaller the hole through which the light was projected, the sharper the image.

Camera obscura

Over the centuries, awareness of this principle led to the development of the *camera obscura*. The camera obscura is a darkened room with a small hole in one wall through which light rays pass, forming an inverted image of the scene outside on the wall opposite the hole. In the 10th century the Arabian philosopher, Alhazen, used a form of camera obscura to view eclipses of the sun. By the 15th century the principle behind the camera obscura was widely known – by Leonardo da Vinci amongst others.

By the middle of the 16th century several people had pointed out the benefits of using a lens in the hole to obtain a clearer and brighter image. An Italian, Giovanni Battista della Porta, suggested both the use of a lens to improve the sharpness of the image, and pointed out that the camera obscura could be used as an aid to drawing – the 'artist' drawing round the image produced by the camera obscura.

By the 17th century portable versions of the camera obscura, made like small boxes, were in use as aids to drawing and there were even sedan chair camera obscura which could be carried from place to place. In the form of a 'dark room' the camera obscura became a popular attraction. Usually housed in a tower to give an extensive view of the surrounding countryside, a lens and a mirror were used to throw an image of the view on a circular table.

Recording the image

By the end of the 18th century a number of people were experimenting with ways of recording the image formed by the camera obscura.

In the 1720s a German professor, Johann Heinrich Schulze, had observed the effect of light on silver salts. While trying to make phosphorus, Schulze had mixed chalk, nitric acid and silver. He was surprised to see that the mixture turned dark purple when exposed to light.

A Swedish chemist, Carl Wilhelm Scheele, established that the darkening effect of light on this mixture was due to the formation of metallic silver.

Thomas Wedgwood
In England, at the turn of the century, Thomas Wedgwood, son of the potter Josiah Wedgwood, used paper sensitized with

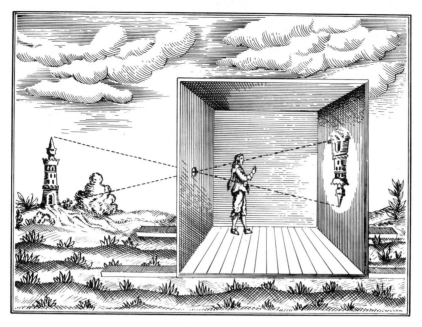

◁This old print illustrates the principle by which the camera obscura works.

silver nitrate and silver chloride to try and record an image. His friend, Humphrey Davy, recorded the experiments in the *Journal of the Royal Institution* in 1802.

Wedgwood and Davy produced copies of leaves and of the paintings on glass which were fashionable at the time on their sensitized paper but the problem was that the images could not be fixed. The paper continued to react to light after the leaf or whatever was removed and so the images could only be viewed by candlelight, for otherwise they darkened all over.

The first photograph

In 1826 Joseph Nicéphore Niépce, a Frenchman, succeeded in taking what is geneally considered to be the first photograph – the first permanent picture by the action of light. To achieve this he used a pewter plate coated with a thin layer of bitumen. Bitumen hardens when exposed to sunlight, so the coating became

hard on the parts of the plate exposed to light and remained soluble on the parts of the plate which were in shadow. When Niépce washed the plate with a solvent he was left with a permanent positive (as opposed to a negative) picture in which the light areas were represented by hardened bitumen and the shadows by bare pewter.

This heliograph (sun drawing), as Niépce called it, took eight hours to record. The photograph, which still survives, shows the view from Niépce's workroom window.

The Daguerreotype

Before Niépce died he went into partnership with another Frenchman – Louis Jacques Mandé Daguerre, who was also interested in recording the image formed by the camera obscura. By 1837 Daguerre had developed and improved on Niépce's work. Daguerre worked with copper

plates coated with a layer of silver iodide. After the exposure had been made the image was not visible – it had to be 'brought out' by the plate being exposed to mercury vapour.

Where light had touched the plate minute specks of metallic silver had formed. These specks were affected and made visible by the mercury vapour. The unaffected silver iodide could be washed away, leaving a clear, permanent image. The end result – the Daguerreotype – was an attractive, detailed, positive picture in which the lighter areas of the subject were represented by the white mercury/silver amalgam and the darker areas were shown by the polished surface of the silver. The delicate surface had to be protected by glass and it

had to be sealed to prevent the silver tarnishing.

Daguerreotypes became very popular and studios were opened in many towns in Europe and America. As well as portraits, Daguerreotypes were used by travellers to record and document their journeys.

Fox Talbot

In the meantime, an Englishman, William Henry Fox Talbot, was busy experimenting by taking photographs at his house, Lacock Abbey in Wiltshire. In 1841 he patented the Calotype (later called the Talbotype) process for making positive prints from paper negatives – the birth of modern photography.

Previous experimenters like Niépce and Daguerre had concentrated on obtaining a direct positive – a picture in which the black areas were black and the white areas white with no intermediate negative being necessary. Fox Talbot used paper sensitized with silver salts to record his negative images. Where the light fell on the paper it darkened. Where no light fell it remained white.

The resulting negatives could at first only be viewed in dim light as bright light meant the process continued and the whole paper darkened. Then Sir John Herschel, hearing of Fox Talbot's work, informed him of his own discovery that hyposulphite of soda (sodium thiosulphate) dissolved silver salts and could therefore be used to fix the image by removing the excess salts once the exposure had been made.

Talbot went on to develop his process. He realized that he could

make his negative into a 'normal' positive picture by passing light through the negative on to another piece of light sensitive paper. And best of all – from the original negative any number of copies could be made.

A further development came from Talbot's realizing, as Daguerre had earlier, that he did not need to leave the sensitive paper exposed to light in the camera until the image became visible. The paper could be treated or *developed* with chemicals, after a much shorter exposure to light, to produce a sharp, clear image.

Even so Fox Talbot's process had the disadvantage that the exposures still needed to be fairly lengthy and that the grain of the paper negatives appeared in the final prints.

The wet collodion process

These problems were overcome in the wet collodion process described by another Englishman, Frederick Scott Archer, in 1851. This used a glass plate which was coated with a solution of collodion (a form of guncotton in ether) and allowed to dry. Immediately before making the exposure the plate was sensitized by dipping it into a solution of silver nitrate. It was necessary to expose and develop the plate while it was still wet, so the photographer had to carry a temporary darkroom with him. Balanced against this disadvantage were the advantages of fine, detailed negatives and an exposure time of only a few seconds. The collodion negative could then easily be printed on light sensitive paper. The process

One of Matthew Brady's pictures taken at the time of the American Civil War.

rapidly became very popular.

In 1855, Roger Fenton, an Englishman, took photographs of the Crimean War using the collodion process – the first photographic records of such an event. He used a horse drawn wagon converted to a darkroom for his work. In America Mathew Brady took similar pictures of the American Civil War in the 1860s.

The dry plate

During this period the photographer had to make his own plates as he needed them, but in 1871, Richard Leach Maddox, an English doctor, announced his discovery that dry plates could be produced by mixing a solution of gelatin with cadmium bromide and silver nitrate. The resulting 'emulsion' contained silver bromide and could be coated on glass plates or paper and used when dry. Further developments of this process followed swiftly. Soon dry plates which were very sensitive to light were being manufactured commercially and

were being widely used. Exposure times were now greatly reduced – to only one quarter of a second or less. This development had a considerable effect on camera design.

Camera design

The camera has gone through many changes in the course of its history. Fox Talbot for his early experiments used several 'cameras' which were 76 millimetre cubes. One of these, now in the Science Museum at South Kensington, London, had a 29 millimetre hole in the front in which

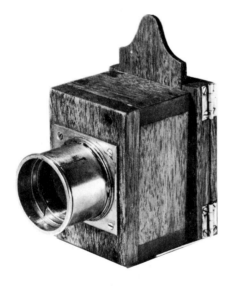

▷ One of Fox Talbot's small 'mousetrap' cameras

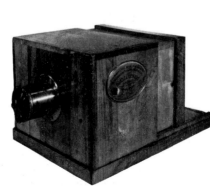

▷ A Daguerreotype camera made in 1839.

Fox Talbot fitted a lens from his microscope. The back was hinged so that sensitive paper could be pinned on it. These cameras and others used by early photographers were made by the photographers themselves.

The first cameras to be manufactured and sold commercially were for the Daguerre process. A number of these were produced in the 1840s. They consisted of a double box, one sliding inside the other to enable the lens to be focused.

The invention of the dry plate in 1871 made photography a practical proposition for the general public. A number of cameras were marketed. Most of these were made by cabinet makers in beautifully finished mahogany with brass fittings. The lens was mounted on a panel which slid backwards and forwards on rails and was linked by a leather bellows to the rear section of the camera which held the plate.

In these early cameras the image was viewed and focused on a piece of ground glass which was placed at the rear of the camera. When the scene had been focused a plate holder was put in place of the ground glass screen and the exposure made.

The reflex camera, in which the image is reflected by a mirror to a ground glass screen on the top of the camera, was introduced to avoid the difficulties of this procedure. When the shutter release is pressed on a reflex camera the mirror tries to allow rays to reach the plate.

The most important innovations towards the end of the 19th century from the point of view of the man in the street were the cameras introduced by George Eastman of America.

George Eastman

George Eastman became involved with photography before the development of Maddox's dry plate idea. As an enthusiastic amateur he took many photographs using his own wet plate apparatus. Then he read about the dry plates and began experimenting. His first invention was a plate-coating machine which made producing the dry plates much quicker and easier. This was patented in America in 1879. Soon Eastman was manufacturing his own dry plates for sale to the general public.

He continued to experiment and to seek improvements, looking for an alternative to the awkward and fragile glass plate. The result was a roll of paper coated in a gelatin emulsion. The thin paper could be made translucent after processing by using wax or castor oil so a positive print could be made by passing light through it.

This roll of negative paper could be fitted on to a roll holder and the roll holder used to replace the plate holder in most standard cameras. The roll was long enough for up to 24 exposures, and the device became very popular.

Eastman went on to develop a new, small, simple camera incorporating the roll holding mechanism. In 1888 the first Kodak camera was launched. (The name Kodak was invented by Eastman who wanted his own, easily-pronounced trademark.) The advertising campaign promoting the new camera emphasized: 'You press the button, we do the rest.' For the camera was sold loaded with a roll of film

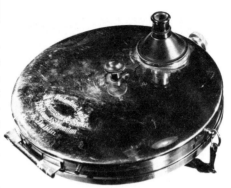

giving 100 exposures. When the pictures were all taken, the photographer returned the whole camera to Eastman's factory, where the film was removed, and developed. The customer then received back the camera reloaded with film plus the processed negatives and prints. At last photography was made really accessible to everyone and the new Kodak camera was an enormous success. Eastman had revolutionized photography.

Further improvements followed: a transparent film made from celluloid was developed in Eastman's laboratories. New cameras were introduced, including the Pocket Kodak, and in 1900

△ A 'detective' camera. It could be hidden beneath the photographer's waistcoat with the lens sticking out from a buttonhole!

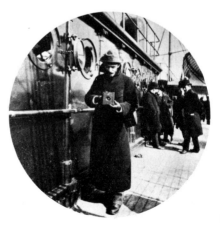

◁ George Eastman and one of his cameras.

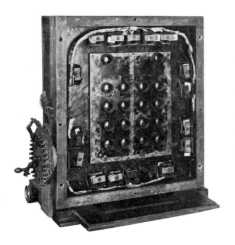

A sixteen-lens camera made in 1887.

An advertisement issued in 1885 for Eastman's roll holder and negative film.

Eastman launched the Brownie camera. This simple box camera was incredibly cheap and meant children could afford to join in the exciting hobby of photography. This camera continued to be popular until the 1930s.

The plate camera

Meantime the plate camera had become smaller in size and also more efficient. In the 1920s and 1930s there were many cameras which folded up into a very small size and used plates 6·5 × 9 centimetres or 8·2 × 10·8 centimetres ($2\frac{1}{2} \times 3\frac{1}{2}$ inches or $3\frac{1}{4} \times 4\frac{1}{4}$ inches). Most of these had 'between-lens' shutters which gave a wide range of speeds between one second and 1/250 second.

The next great advance was the arrival of the 35 mm camera using cine film and taking negatives 24 × 36 millimetres. As early as 1913 Oscar Barnak who worked for the Leitz optical firm in Germany made a small camera using 35 mm cine film for testing lenses. He decided that the normal frame size of 18 × 24 millimetres was too small and therefore designed a camera to take frames of 24 × 36 millimetres – the accepted 35 mm format of today. The 1914-18 war held up development and it was not until 1925 that the camera went into full scale production.

In 1936 the first 35 mm single lens reflex, the Ihagee Kine Exakta, appeared. This had a viewing screen on the top of the body which showed the image of the scene in reverse. In 1950 this type was improved by the introduction of a pentaprism which produces a right way up right way round image in the viewfinder.

Cartride type film was introduced in 1963 by Kodak. At first this was in the 126 size but later the 110 size was introduced and this has since become very popular.

In 1947 Dr Edwin Land announced his invention of the Polaroid instant picture process and in 1963 he introduced instant colour pictures.

The development of colour photography

One of the first successful processes was invented by a professor at the Sorbonne in Paris, Gabriel Lippmann in 1891. This worked on the principle of 'interference' – the same principle which produces colours in soap bubbles and in oil patches on wet roads. Unfortunately the process was too complicated to be successful commercially.

As early as 1666 Sir Isaac Newton had discovered that normal 'white' light is made up of a mixture of all the colours we ever see. (You can see for yourself that white light can be split into its component colours by using a prism.) In 1861 Clerk Maxwell managed to demonstrate that almost any colour can be made by mixing the three primary colours – red, blue and green. (In painting lessons you may have been told that the primary colours are red, blue and yellow. These apply to *pigments* – which when mixed behave differently to mixed coloured *light*.)

Maxwell himself didn't go on to develop the process but others did. In 1893 John Joly of Dublin invented a way of making a colour picture without taking three separate pictures through three different filters. He took one negative through a screen covered in tiny areas of red, green and blue. The screen was put on the front of the photographic plate, and after the plate had been developed and a transparency made from it, the screen was fixed to the transparency. The black, grey and white areas of the transparency allowed varying degrees of light to shine through the coloured screen. Viewed from a short distance the light shining through the mixture of primary colours on the screen reproduced the colours of the original scene. In France the Lumière brothers developed this technique – putting on the market in 1907 photographic plates covered in minute dyed grains of starch.

A modern colour film has three very thin layers of emulsion. These layers divide up the light which falls on to them – each layer recording a different primary colour. The top layer is sensitive to blue, the middle to green and the bottom to red. Colours which are a combination of the primary colours are recorded on more than one layer of film.

Films incorporating this solution to the problem of recording colour were first successfully introduced in the 1930s as Kodachrome. This was colour transparency film; the first colour negative film (from which ordinary prints could be made) available to the general public was Kodacolor film in the 1940s.

The development of photography as an art

Many of the early photographers combined prints from several negatives to make pictures which were similar to the work of the artists of the time. One of the best known workers in this field was O. G. Rejländer, who was born in Sweden but settled in England. His famous picture *Two Ways of Life* (1857) shows Virtue and Industry on one side and Vice and Pleasure on the other, with an aged philosopher giving two youths the choice.

Mrs Julia Margaret Cameron (1815-79) took many photographs of 'cherubs' and 'angels'. This was so popular that a photographic manual of the 1860s described ways of making wings for 'angels' from those of ducks.

In the early decades of this century photographers became enthusiastic about the gum and bromoil printing processes. In the bromoil process the original photographic image was transformed into a gelatin one and the picture was made by brushing oil pigment over this. The result was completely under the control of the photographer and the final print resembled a monochrome oil painting.

Into the 1920s photographers produced pictures which were inspired by the traditions of painting. Landscapes were dreamy detailed affairs which were often sepia toned.

The invention of the 35 mm miniature camera brought a new outlook to photography. The freedom of movement first led to a new look in portraiture. Dr Erich Salomon, a German, took 'candid' shots at important political gatherings and Alfred Eisenstaedt, another German, took portraits which caught the living person rather than the posed image of the studio.

In landscape work, one of the great innovators was the American Edward Weston. He took many of his most famous pictures in Mexico where the vast scale of the scenery and rocks provided scope for his work.

From these beginnings photography has developed into an art form of its own. On the journalistic side Henri Cartier-Bresson is famous for his photographs taken at what he has called the 'decisive moment'. Completely unposed and taken while the persons around are unaware of him, the pictures have a special reality. In England Bert Hardy who worked for the magazine *Picture Post* took many similarly telling pictures and Bill Brandt has produced many landscapes and other pictures which rely on the true basis of photography – light and form.

Now photography has broken away from the traditions of painting and has become an art form in its own right.

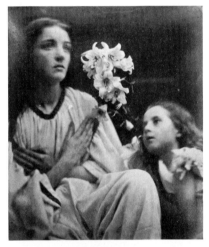

One of Julia Margaret Cameron's 'angel' pictures.

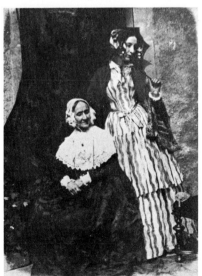

'Lady Eastlake and Mrs Rigby', taken by Hill and Adamson.

INDEX

Numbers in **bold** refer to illustrations.